LAND AND LIGHT IN THE AMERICAN WEST

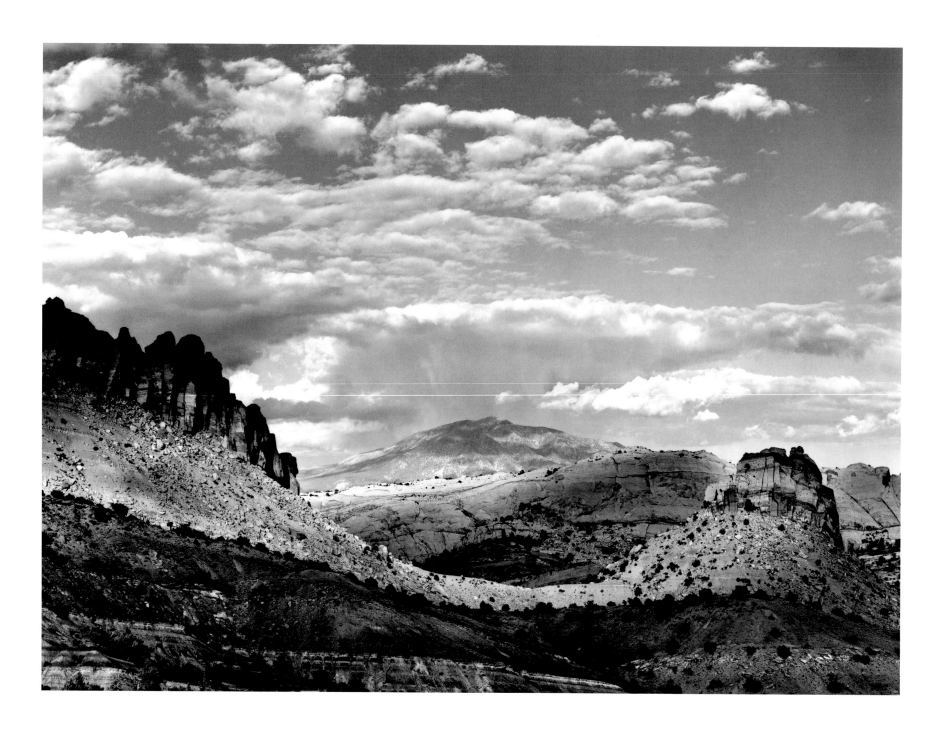

LAND AND LIGHT
IN THE AMERICAN WEST

PHOTOGRAPHS BY

JOHN WARD

INTRODUCTION BY WILLIAM R. THOMPSON
FOREWORD BY BECKY DUVAL REESE

TRINITY UNIVERSITY PRESS, SAN ANTONIO
IN ASSOCIATION WITH THE EL PASO MUSEUM OF ART FOUNDATION

This book accompanies the exhibition *Land and Light in the American West: Photographs by John Ward*, organized by the El Paso Museum of Art and presented there from January 8 to March 27, 2005.

Published by Trinity University Press
San Antonio, Texas 78212

Frontispiece: Henry Mountains and Waterpocket Fold, Capitol Reef National Park, Utah, 1984

Designed and typeset by Karen Schober.
Text set in Caslon and display set in Avenir. The photographs were reproduced in the Fultone® process and printed under the direction of David Gardner on 100 lb. Vintage gloss book by Dual Graphics, Brea, California. Bound by Roswell Bookbinding, Phoenix, Arizona.

⊚The paper used in this publication meets the minimum requirements of the American National Standard for Information Sciences—Permanence of Paper for Printed Library Materials, ANSI Z39.48-1992.

Library of Congress Cataloging in Publication Data

Ward, John, 1943–
Land and light in the American West: photographs / by John Ward; introduction by William R. Thompson; foreword by Becky Duval Reese
 p. cm.
"This book accompanies the exhibition Land and Light in the American West: photographs by John Ward, organized by the El Paso Museum of Art and presented there from January 8 to March 27, 2005."
ISBN 1-59534-004-1 (hardcover : alk. paper)
1. Landscape photography—West (U.S.)—Exhibitions. 2. West (U.S.)—Pictorial works—Exhibitions. 3. Ward, John, 1943—Exhibitions. I. El Paso Museum of Art. II. Title.
TR660.5.W37 2004
779 .3678 092—dc22 2004008883

DEDICATION

Dedicated without permission to the inner circle,

five photographers who generously shared knowledge,

inspiration, and friendship:

JIM BONES

BILL LEES

DAVID RATHBUN

RAY WHITING

RONALD WOHLAUER

FOREWORD

THE EL PASO MUSEUM OF ART has a long and proud history of collecting the work of artists from the American West. In 1997, the Museum was fortunate to acquire ninety gelatin silver prints by Colorado-based photographer John Ward through the generosity of collector James Haines. One of the largest bodies of work by a single artist in the Museum, these prints collectively form a very personal view of the West, which Ward has been photographing in earnest since the late 1960s.

The presence of Ward's photographs in the Museum has been significant in many ways. One of the focal points of our growing photography collection, his prints have inspired additional acquisitions, and discrete selections of his work have been included in several recent exhibitions. For some time it has been the Museum's goal to present a more comprehensive view of Ward's photography in conjunction with an accompanying publication. *Land and Light in the American West* features sixty photographs personally selected and sequenced by the artist as representative of his finest work with an introductory essay by William R. Thompson, the Museum's former curator.

This publication also represents the first collaboration of its kind between the El Paso Museum of Art and the El Paso Museum of Art Foundation, which was established in 1999 to support the Museum's ongoing activities, from acquisitions and conservation to educational programs and special exhibitions.

On behalf of the Museum, we are grateful to James Haines for his gift of the works of John Ward, which will be shared with our visitors for years to come. We likewise thank the El Paso Museum of Art Foundation for its ongoing support and for enabling us to reach audiences far beyond our walls. To John Ward, we join together to give thanks for his dedication to his art and to the landscape of the West. His vision reveals a heartfelt sense of discovery and appreciation for the beauty around us.

—Becky Duval Reese
Director

INTRODUCTION

ON THE MORNING OF MAY 25, 1976, John Ward stood his 8-by-10-inch view camera in front of two young cottonwood trees in Colorado's Great Sand Dunes National Monument, a vast expanse of shifting, sun-bleached sand at the foot of the Sangre de Cristo Mountains. He took only two pictures of the trees on that day before breaking camp and continuing on his journey home to Boulder, Colorado, where he later developed the film. Recognizing an image of uncommon potential, Ward chose to print from the very first negative he exposed that day and spent months working with it before producing a finished photograph. Every square inch of the negative confronted him with considerable technical hurdles, from balancing the dunes' subtle dance of light and shadow to articulating the nearly imperceptible animal tracks running across the foreground. Ward's interpretation of the image continued to evolve with each reprinting over the next several years as he struggled to come to terms with its formal nuances. As with virtually all of his works, he gave the print a simple yet precise title, *Trees on Dune, Great Sand Dunes National Monument, Colorado,* 1976 (Plate 26).[1]

A subdued, introspective scene and one of many hundreds in Ward's archive, *Trees on Dune* nonetheless stands as a milestone in the artist's career. More than twenty-five years later, Ward views this single photograph as his magnum opus and an essential autobiographical statement.[2] The pensive solitude of the cottonwoods surrounded by the stark, wind-swept dunes gently speaks of Ward's journey as an artist and, more broadly, the human condition. Printing this difficult photograph continues to challenge Ward's formidable darkroom skills and is a testament to his ongoing pursuit of aesthetic and technical perfection. Hoping to produce a better negative, Ward returned to the same site in 1978 to photograph the trees again, but he was unable to surpass the grace of that original encounter. Like so many great photographs, *Trees on Dune* was lightning in a bottle, a fleeting moment made divine through extraordinary skill and a touch of serendipity.

Ward arrived at photography through the study of science, not art, and mastered the medium's most difficult techniques without formal instruction, relying instead on careful observation and

methodical experimentation. Trained as a physicist, he has spent a lifetime investigating the very nature of light, first in the laboratory, now in the darkroom. In 1970, while still a graduate student, he discovered the photographs of Ansel Adams and Eliot Porter, and their breathtaking imagery and commitment to the natural world resonated powerfully with his own values. Ward ultimately decided to pursue a career as a photographer instead of as a scientist. An unapologetic traditionalist, he has gone about his work independently, with little concern for the trend-conscious art world. Since the early 1970s, Ward has worked almost exclusively with a large-format view camera, an elegant but demanding instrument that produces images of unsurpassed clarity and tone. While he is well versed in both color and black-and-white processes, the latter remains at the heart of his oeuvre and connects him most directly to the modernist vision of Adams, Edward Weston, and the other pioneering photographers of Group f/64.

Ward explores the rhythmic splendors of land and light with his camera. Lyrical and intelligent, his photographs illuminate the complex and ever-changing relationship between humanity and the natural world, all the while reflecting the artist's concern for preserving the country's dwindling natural heritage. During the past three decades, Ward has photographed secluded landscapes and architectural ruins throughout the United States, from the thick forests of rural New England to the rugged shores of the Pacific Coast. Based in Colorado for most of his life, Ward has developed a particularly strong affinity for the expansive deserts, national forests and parks, and wilderness areas of the American West, which figure prominently in his work. His photographs of these and other subjects reveal a profound eloquence, reverence for the land, and the foremost technical achievement.

John Ward was born on March 23, 1943, in Washington, D.C. His father, Frederick, studied chemistry before being drafted into the army and eventually joining the U.S. Geological Survey. His mother, Loraine, worked as a secretary long enough for the family to qualify for a mortgage and then left her job to raise John and his sister, Margaret, who was born in 1945. Frederick and Loraine Ward had come of age during the Great Depression and, like so many of their generation, had learned out of necessity the virtues of being frugal and practical. They lived modestly and aspired to provide their children with a secure, middle-class upbringing. Their first home was located in Berwyn, Maryland, a suburban enclave off U.S. Highway 1, the main artery connecting Baltimore and the District of Columbia. The home was part of a typical postwar subdivision and had been built next to dense, second-growth woods, which offered the neighborhood children endless hours of diversion. Living so close to wilderness as a youngster would have a significant impact on Ward in the years to come.

Ward recalls being fascinated with the physics of light from a very early age. His inquisitiveness was sparked further after he was introduced to the camera through his father, who taught himself how to develop film and prints to accompany his presentations at work. Over time, Frederick Ward's interest in photography grew fairly serious. According to family lore, the elder Ward

once ventured out to buy a new suit for which he had diligently saved and instead returned home with a 35mm camera, the first of many he would eventually acquire. He often took pictures of his family during trips, birthday parties, and backyard gatherings. On occasional evenings, the kitchen was turned into a makeshift darkroom, and the young Ward watched with curiosity as his father made contact prints from his negatives. He vividly recalls the alchemy of the stop bath, which bubbled and hissed when the photographs were immersed in it. Ward's grandmother later gave him a roll camera of his own. It was a splendid gift, particularly for a boy just beginning to discover the world of science, although he never imagined it as a prelude to his life's work.

In 1952, the Wards moved to a larger home in Silver Springs, Maryland, which was also adjacent to woods with trails and streams. The house was purchased under the assumption that Frederick Ward's job with the U.S. Geological Survey would remain close to Washington, but in the following year he was unexpectedly transferred to Colorado. The Wards sold their Maryland home and bought one in the southwest corner of Denver near the neighborhood of Loretto Heights, then the very edge of the city. Surrounding the subdivision was the rolling prairie of Colorado's eastern plains, while to the west stood the majestic Rocky Mountains, dominated by the snow-capped profiles of Long's Peak to the north, Mount Evans to the west, and Pike's Peak some sixty miles to the south. Ward, then ten years old, began to explore the acres of undeveloped land near the family's residence. When he reached his teens and obtained a driver's license, he traveled on his own into the mountains to climb and hike, drawn to their exhilarating heights and stillness. In the late 1950s, the Rockies were sparsely populated and largely devoid of the ubiquitous summer homes and resorts one finds there today. Ward sometimes brought along his father's cast-off cameras to document his excursions. "I took pictures then, usually of the summit and from the summit, but it never occurred to me that a photograph could be more than a trip record," he later wrote.[3]

Ward was a brilliant student and, like his father, deeply interested in the sciences, especially chemistry. He attended West and Abraham Lincoln High Schools in Denver and excelled at college-level science classes, often spending his free time reading books about light and other subjects and experimenting in the school laboratory. Ward graduated second in his class in 1961 and took a summer job as a research assistant in the Water Resources Division of the U.S. Geological Survey, where he cleaned lab equipment and worked on a method to determine the amount of arsenic in water. In the fall, he left Denver for Cambridge, Massachusetts, to attend Harvard University, which he entered as a sophomore. Most of his time in college was devoted to physics and mathematics, but Ward also took courses in chemistry, economics, religion, and philosophy. Accustomed to taking an extra course each semester in high school, he developed the habit of auditing additional classes at Harvard, usually in physics or the humanities. When not studying, Ward sometimes photographed the aged streets and buildings of Cambridge in color using a 35mm camera brought from home. It was a welcome release from the routine and pressures of academia, but he was mostly unsatisfied with the results, which to his eye seemed overly pretty and sanguine. In his senior year,

Ward worked as a research assistant in Harvard's Division of Engineering and Applied Physics, where he met a fellow student who also had been photographing the local street life, but with black-and-white film. Intrigued with the expressiveness of these prints, Ward purchased additional supplies and used a darkroom at the school to make his first gelatin silver prints.

Ward graduated from Harvard in 1964 with a B.A. in physics and returned west to pursue a doctorate in the field at the University of Colorado at Boulder. He found the first-year curriculum tedious and repetitive. A self-described "night owl," Ward claims that he made it to his midmorning quantum mechanics lectures only because he happened to be auditing a course on Shakespeare held during the previous hour. A sympathetic professor recommended him for a research position at the Joint Institute for Laboratory Astrophysics, a collaborative venture between the university and the National Bureau of Standards. Ward joined an ambitious project to measure the speed of light with increased precision. An abandoned gold mine in a canyon west of Boulder was leased for the experiment, which required the construction of a lengthy vacuum chamber. Ward helped outfit the laboratory with the necessary instrumentation. By coincidence, he shared office space with a colleague who was also interested in photography and responsible for overseeing the lab's darkroom. With access to this facility, Ward renewed his interest in photography. He purchased a new 35mm camera and began photographing landscapes in and around Boulder.

In 1966, Ward married Susan Etter, a recent graduate of Tufts University, whom he had met several years earlier while they were both in college. Susan had majored in occupational therapy, and the couple became engaged in 1965 when she came to Denver to complete two clinical affiliations required for her degree. A naturalist at heart with a special interest in birds, she shared Ward's adventurous spirit and love of the outdoors. The couple went on the first of their many camping trips together in the spring of 1967. As Ward pursued his studies in physics, he continued to grow more interested in photography. He became acquainted with several other students who shared his passion for the camera and attended gatherings where the group socialized and critiqued their slides.

Eager to learn as much as possible about the medium of photography, Ward looked to the work of two masters, Ansel Adams and Eliot Porter. By the late 1960s, Adams had yet to reach the peak of his celebrity and sales records but nonetheless was regarded as a singular force in American photography. His heroic imagery of the West redefined the landscape tradition for a generation of artists, and his work on behalf of the Sierra Club played a critical role in the development of the modern environmentalist movement. With his days in the field mostly behind him, Adams spent his final years at his home in Carmel, California, where he directed his considerable energies into publishing projects and filling orders for his prints.[4] Renowned for his technical expertise, he had authored a number of important instructional manuals throughout his career, beginning with the first volumes of his influential *Basic Photo Series* in 1948. The books have remained standard references for amateur and professional photographers alike, and Ward found

these, as well as other monographs of Adams's works, extremely useful as he learned to manipulate the camera and to develop film and prints on his own.[5]

While Adams was at the forefront of black-and-white photography, Eliot Porter pioneered the use of color and by the 1960s was considered one of its leading practitioners. Trained in the sciences, Porter had taught at Harvard Medical School before devoting himself to photography and environmental advocacy. A careful observer of nature, he was best known for his introspective landscapes and studies of birds. In 1946, Porter moved to Tesuque, New Mexico, where he spent the next four decades publishing books and working on special projects. Like Adams, he was closely involved with the Sierra Club, which in 1962 published his groundbreaking monograph *"In Wildness Is the Preservation of the World," Selections and Photographs by Eliot Porter*. Four years later, the Adirondack Museum in Blue Mountain Lake, New York, published *Forever Wild: The Adirondacks*, another acclaimed book featuring eighty of Porter's color photographs along with verse by nature writer William Chapman White.[6] Ward gave the book to his father as a Christmas gift and later bought a copy for himself. Disappointed with the black-and-white prints he was producing at the time, Ward was captivated by Porter's vivid color imagery and sensitive interpretation of the Adirondacks, which fueled his own exploration of color processes and outdoor photography.

In time, Ward's frustration with 35mm black-and-white negatives led to experimentation with 120-roll film in 1968 and on to his first large-format black-and-white photographs in 1969. He made the latter with a discarded 4-by-5-inch Bush Pressman Model D camera that he had found in his parents' basement. It required a tripod and was more laborious than the smaller 35mm cameras he had been using, but the device offered greater control of focus and perspective and could render fine details and tones much more effectively. Encouraged by the results, Ward soon purchased a 4-by-5-inch Graphic View II camera of his own and took it with him while hiking in Rocky Mountain National Park, where he created what he now considers his first serious photographs. Among these early works, *Mills Lake, Rocky Mountain National Park, Colorado*, 1969 (Plate 17) stands out as a fine example. Classically framed and tinged with romanticism, the image depicts a flotilla of dead trees swept into the lake by the waters of the spring thaw. In the distance an ethereal band of clouds follows the contour of the surrounding peaks, still heavy with snow but gradually surrendering to the brief warmth of summer.

In addition to their book-publishing endeavors, Adams and Porter produced several limited-edition portfolios during the 1960s. Sponsored by the Sierra Club, these portfolios featured the artists' original prints and celebrated the American wilderness while serving as highly effective visual tools in the growing political struggle to preserve the environment. Around this time the University of Colorado acquired two of Adams's portfolios, *Yosemite Valley* and *What Majestic Word*, as well as Porter's *The Seasons*, which were housed in the campus library.[7] Ward learned of their existence in early 1970 and still recalls the thrill he felt upon opening Adams's *Yosemite Valley* portfolio for the first time and seeing an original print of his masterpiece, *Monolith, the Face of*

Half Dome. Its intense drama and superlative technique surpassed anything that he had seen to that point. Equally inspiring were the twelve photographs included in Porter's *The Seasons*, the first dye-transfer prints that Ward ever encountered. As he worked on finishing his degree Ward returned to the library often to look through the portfolios, sometimes bringing his own prints for comparison. He also experimented with the techniques that Adams documented in the notes accompanying *Yosemite Valley*, and later bought an 8-by-10-inch Calumet camera of his own. In his dissertation, Ward thanked the "persons unknown" who acquired the portfolios for the library, which in his own words "provided renewal for physics, inspiration in other matters and gave value to many an otherwise worthless afternoon."[8]

In December 1970, Ward was hard at work on his doctoral thesis, a continuation of his long-standing interest in the properties of light,[9] when he received a call from David Rathbun, a childhood friend who was visiting his family in Denver. The two had had only sporadic contact with one another since college and, ironically, were unaware that both were pursuing photography along very similar lines. After graduating from Wheaton College in 1965, Rathbun studied theology and philosophy at Princeton University and went to work in Harlem for the Street Academy Program administered by the Urban League. He later joined Norman Kurshan Inc., the premiere color photography lab in New York, where he was introduced to Eliot Porter. Rathbun had been offered a five-year position as an assistant in Porter's studio and was en route to his new job in New Mexico when he telephoned Ward, who at first was incredulous that his friend was going to work for one of his idols. In the summer of 1971, after Ward finished work on his dissertation, he and Susan drove to Tesuque. Porter was away from home at the time, but Rathbun gave the Wards a private tour of the studio and a demonstration of the dye-transfer process, a complicated technique for making photographic prints using three color-separated negatives and dye baths. Ward was intrigued with this challenging method, which offered greater control of color and produced vivid, durable images.

After completing his graduate studies, Ward accepted a one-year appointment as an assistant professor in the physics department at Lawrence University, a liberal arts college in Appleton, Wisconsin. His first teaching assignment was the one class in the entire physics curriculum that he had never taken or studied—introductory physics without calculus—and he found the task far more challenging than expected. Ward was left with little time for hiking or photography, but he nonetheless managed to create his first negatives using the 8-by-10-inch Calumet camera that he had purchased in graduate school. He described the experience of learning to use this new equipment as "starting over from scratch," and while the initial results were unsatisfactory, he immediately recognized its potential for producing images of superb quality. After finishing his teaching assignment at Lawrence, Ward was offered a position at Argonne National Laboratories near Chicago, which he declined in favor of returning to Colorado. The Wards missed the arid climate and dramatic scenery of the West, and John was eager to devote the upcoming year to travel

and photography. Having sublet their Boulder apartment for a full year, they returned to Colorado and headquartered in the Lakewood home of Frederick and Loraine Ward, who were living overseas at the time. With his father's permission, Ward built his first darkroom in his parents' basement, where he refined his printing skills. The Wards returned to their Boulder apartment in the fall, but John regularly commuted the thirty miles to his parents' home for the next few years to use his darkroom. Although he had introduced his son to the camera and was a supportive parent, Frederick Ward had difficulty accepting that John was more interested in becoming an artist than pursuing a more pragmatic and financially rewarding career as a scientist. Ward followed his heart, however, and gradually the year that he had planned to devote to photography would stretch into a lifetime.

In 1972, the Wards embarked upon a lengthy camping trip that took them across the country. In addition to exploring the Rockies, they traveled to both coasts in their Volvo, spending considerable time in New England as well as the Pacific Northwest. Along with their tent and camping supplies, Ward brought along his 4-by-5- and 8-by-10-inch view cameras and learned how to pack and travel efficiently with this delicate and heavy equipment. Susan was an indispensable partner on their excursions, and she worked closely with John in the field. It could take an hour or more to photograph a single subject, depending on how long it took to set up the camera and wait for the proper light and weather conditions. The window of opportunity was often brief, and Ward selected his subjects with care. He returned home to develop his negatives, which he viewed as preparatory notes for his finished prints. During that year, Ward worked intensely in the field and processed hundreds of negatives and prints in the darkroom at his parents' home, including *Black Rock, Olympic Coast, Washington*, 1972 (Plate 9); *Tree in Fog, Olympic Coast, Washington*, 1972 (Plate 4); and *Stream and Logs, Mount Rainier National Park, Washington*, 1972 (Plate 20). These early examples possess many of the same qualities characteristic of Ward's mature black-and-white work: a crisp, modernist vocabulary; a mastery of technique; and a wistful sense of isolation and passing time.

The 1970s were a vital decade for photography. After more than a century of relative indifference to the medium, the art world began to recognize the camera as a valid and dynamic form of artistic expression. A number of museums began to actively collect and exhibit vintage and contemporary prints around this time, and several new institutions devoted exclusively to photography were founded, most notably the Center for Creative Photography, established in 1975 at the University of Arizona in Tucson.[10] Despite renewed appreciation for the medium, opportunities for photographers to show their work in museums and galleries remained fairly scarce. Ward's first public exhibition took place in 1973 at Lodestone Gallery in Boulder.[11] Later that year, the pioneering photographic historian and curator Beaumont Newhall, then visiting professor of art at the University of New Mexico, selected three of Ward's photographs, including *Mist at Ouzel Falls, Rocky Mountain National Park, Colorado*, 1970 (Plate 19) and *Black Rock, Olympic Coast, Washington*, 1972 (Plate 9), for inclusion in the *Southwestern Photography Exhibition* at the Dallas

Museum of Fine Arts.[12] It was Ward's first juried exhibition, and Newhall's involvement attracted a talented field of the region's emerging photographers, such as Keith Carter, Robert Bruce Langham III, and Geoff Winningham. Colorado's photographic community at this time was fairly small, but several venues in the state began to present exhibitions, including the University of Colorado at Boulder and The Darkroom, a rental photography lab in Denver. The Darkroom regularly featured works by contemporary photographers based in the western United States, and Ward had solo exhibitions there in 1975, 1977, and 1978.

Ward's growth as a photographer during this time was guided in part through his association with a close-knit network of friends. In addition to Ward, the group's core members included David Rathbun, Jim Bones, Ronald Wohlauer, Ray Whiting, and Bill Lees. Rathbun first met Jim Bones, who was likewise working with color film, through Eliot Porter's studio and introduced him to Ward. A native of Louisiana, Bones studied photography with Russell Lee at the University of Texas at Austin and had recently concluded a fellowship at Paisano Ranch, the Hill Country retreat of writer J. Frank Dobie, which resulted in his book *Texas Heartland*.[13] Bones later succeeded Rathbun as an assistant to Porter. Ward made his first dye-transfer prints in Bone's Tesuque darkroom in 1977.

Ward's introduction to Ronald Wohlauer came through their common photography dealer in Boulder. Wohlauer had earned his M.A. at the University of Oregon, where he wrote his thesis on the photographer Brett Weston. Well versed in the history of photography, Wohlauer curated exhibitions at The Darkroom and joined the faculty of Community College of Denver in 1975. His friendship with Ward began one day in 1973 when he called John to borrow a specific camera lens for a commercial job. The lens would not fit Wohlauer's camera, so Ward loaned Wohlauer both his camera and a new lens. In gratitude, Wohlauer left Ward the kind of thank-you a photographer most appreciates: a beautiful print. Later Wohlauer loaned Ward the light source that Ward used to make his first 16-by-20-inch enlarged prints from 8-by-10-inch negatives.

Through Wohlauer, Ward met Ray Whiting, who had joined the faculty of Community College of Denver in 1976. Whiting had studied painting at Denver University and first worked as a commercial art director. He became interested in large-format photography in 1964 while traveling in Mexico with Brett Weston and Don Ross. Upon returning to San Francisco, he purchased an 8-by-10-inch view camera and began to pursue photography seriously. After earning an M.F.A. from Ohio University in 1973, Whiting shifted to the 11-by-14-inch view camera. He and Ward carried on extensive discussions and experiments concerned with uniform development techniques for large-format negatives. Ward also constructed an extension that allowed Whiting to print from 11-by-14-inch negatives using an 8-by-10-inch Durst enlarger.

Prior to the Lodestone exhibition, Ward exhibited a few photographs at sales of the Boulder Potter's Guild, of which Susan was a member. These caught the eye of Bill Lees, who introduced himself to Ward and showed him some of his prints. The two became fast friends. A self-taught

photographer, Lees worked as a precision instrument maker, initially in the aerospace industry and later at the Joint Institute for Laboratory Astrophysics (where Ward had been a graduate student), before establishing his own company, Lees Optical. Lees had covered much of the same technical territory Ward was exploring, and he later lent John his densitometer and sensitometry notes and helped build his Boulder darkroom. Lees also designed and fabricated a special backpack to accommodate the bulky 8-by-10-inch camera. On one occasion when the Wards encountered car trouble during a photography trip, Lees towed their disabled Volvo more than seventy miles and replaced its timing gear before sending the couple on their way to the Grand Canyon.

Ward's friendship with these colleagues, whom he affectionately refers to as the "inner circle," proved to be instrumental to his development as a photographer. Despite being separated geographically, the group came together often in Colorado and New Mexico, where they critiqued prints, engaged in lengthy discussions about photography, and shared ideas, problems, and solutions. In different combinations, they all photographed together in the field at various times.

Several other figures would influence Ward's career path in meaningful ways. In March 1973, John and Susan again visited David Rathbun in New Mexico and were introduced to Eliot Porter, whose retrospective was being shown in Albuquerque.[14] The group took an unforgettable walk through Santa Fe National Forest, which bordered Porter's property in Tesuque. Porter recognized a similar spirit in Ward—both were Harvard-trained scientists devoted to nature who had turned to photography. Susan also shared Porter's passion for birds. The Wards made visits to Tesuque regularly throughout the 1970s, and when he could Porter generously spent time with Ward and allowed him to study his print archive. Porter's fondness for the Wards was apparent when, several years later, he gave the couple an entire portfolio of dye-transfer photographs from his acclaimed *Antarctica* series, which had recently returned from a traveling exhibition.[15]

In 1974, Rathbun introduced the Wards to another legendary photographer, Laura Gilpin, a native of Colorado Springs who had moved to Santa Fe in the late 1940s. Renowned for her portraits of the Navajo and southwestern landscapes, she likewise offered the couple friendship and encouragement. The Wards shared with Gilpin an interest in the Navajo ruins scattered throughout Arizona and New Mexico, and they often spent time with her on their trips to Santa Fe throughout the 1970s. Ward's *Betatakin Cave, Navajo National Monument, Arizona*, 1974 (Plate 39), which shows the mysterious, 750-year-old remains of Navajo cliff dwellings, was taken close to where Gilpin photographed the site in 1930.[16]

Also in 1974, the Wards' Boulder landlord granted John permission to build a small but fully functional darkroom in part of an unused storage room connected to their basement apartment, which allowed him to devote more attention to perfecting his developing and printing skills. Two years later, they purchased the entire house and, after moving upstairs, enlarged the darkroom and built a studio for Susan's pottery. By this time, Ward was firmly committed to photography, and Susan decided to leave her job as an occupational therapist at Denver Children's Hospital so the

pair could work and travel together. For the next several years, she pursued her interest in pottery and supported the couple by making ceramic beads, which they sold to macramé shops around the country. The business gave them some steady income and the freedom to travel. It also enabled Ward to realize his long-standing dream of purchasing a four-wheel-drive Ford pickup, which he drolly refers to as "the truck bought with beads." The bed of the truck was covered with a small shell, just tall enough for Ward to sit slightly hunched on a seat over one of the wheel wells. He built a set of boxes for the truck to hold cameras and camping supplies and rigged the windows with removable blackout curtains. The result was a vehicle equipped for serious photography, and Ward considers it a major factor in his future work. The blackout curtains permitted him to change the film in his camera in any weather without having to resort to the cramped, dusty interior of a changing bag. The truck could also cover more remote terrain than the Wards' Volvo, and it lessened many of the camping troubles occasioned by inclement weather.

The Wards' photography trips ranged in length from a few days to weeks at a time and took them throughout the country.[17] Between camping excursions, they occasionally stopped to visit family and friends as well as other photographers, museums, and galleries. In June 1974, the Wards took a lengthy trip through Colorado, Utah, Nevada, California, Arizona, and New Mexico. In California, they camped in Yosemite National Park before heading on to Menlo Park and Carmel to visit and look at prints with photographers Wynn Bullock and Brett Weston. The journey also included a short stay with David Rathbun in New Mexico. Ward produced a number of key photographs on this excursion, from the polished, egglike stone in *Rock, Salt Point, California, 1974* (Plate 14) to the weathered adobe walls of *Corner Shadows, Church at San Ildefonso, New Mexico, 1974* (Plate 10).

The Wards traveled primarily in the western United States, but in 1975 they drove to the East Coast, where John made significant photographs in Vermont, Georgia, and other locales. They took their longest trip—nearly six weeks in length—following the death of Ward's mother, Loraine, in the spring of 1978. Traversing the desert Southwest, they stopped to camp in Arizona, New Mexico, and Utah. While in Arizona, Ward created two classic desert images: *Saguaros and Ajo Mountains, Organ Pipe Cactus National Monument, Arizona, 1978* (Plate 2), a group of totemlike cacti standing in silhouette against the magical Sonoran Desert, and *Saguaro Cactus Detail, Arizona, 1978* (Plate 43), an abstracted close-up of the plant's prickly, blistered surface. The images capture Ward's fascination with the hardy plants and spare elegance of the desert, where he feels most at home.

By the late 1970s, the photography market was growing at a brisk pace, and Ward began to sell his prints in a number of galleries. His first substantial sale was in 1977 to Douglas Kenyon Gallery in Chicago, which purchased twenty of his photographs for its inventory and suggested that he increase the scale of his prints from 11 by 14 inches to 16 by 20 inches. Back in his darkroom in Boulder, Ward devised a makeshift enlarging system for his 8-by-10-inch negatives and began

producing the larger photographs. In 1978, he had his first solo exhibitions outside Colorado at Modernage Gallery in New York and the Afterimage Gallery in Dallas. A number of other exhibitions followed in the early 1980s: at Halsted Gallery in Birmingham, Michigan; Hills Gallery in Denver; and Eclipse Gallery in Boulder. Ward reached his widest audience yet in 1981, when *Photography Annual* published a selection of his work, including *Mist at Ouzel Falls, Rocky Mountain National Park, Colorado*, 1970 (Plate 19); *Dos Cabezas, Arizona*, 1978 (Plate 29); *Vineyard, Borrego Springs, California*, 1979 (Plate 28); and *Rico, Colorado*, 1976 (Plate 40).[18]

As Ward developed as an artist, several common themes emerged in his work. Among the most pronounced of these are his melancholic photographs of ruins, part of an ongoing investigation of decay and the cycle of life. Ward has visited many of the abandoned mining towns scattered throughout the American West, and his detailed studies of their weathered facades have offered him the opportunity to work with pure geometric forms, which he has distilled into chaste, modernist abstractions, as in *Rust and Metal, Argo Mill, Idaho Springs, Colorado*, 1974 (Plate 42) and *Broken Board, Victor, Colorado*, 1984 (Plate 12). Although Ward has largely refrained from photographing people, his images of deserted structures like *Boarded Building, Victor, Colorado*, 1983 (Plate 38) and *Matfield Green Elementary School, Kansas*, 1985 (Plate 33) resemble ghostly portraits of absent subjects. Once integral to their small communities, these bleak relics now stand empty on the land, sober reminders of people long gone and civilization's transitory nature.

Ward fluidly investigates themes of change and transition within his landscapes as well. Photographs like *Bentonite Hills, Caineville Wash, Utah*, 1984 (Plate 15) record the remnants of ancient geological events that dramatically reshaped the environment. Others reveal more recent upheavals, natural and man-made. *Black Sand Basin, Yellowstone National Park, Wyoming*, 1982 (Plate 25) shows a cluster of lifeless trees choked by the sulfurous fumes emanating from the earth below, an eerie foreshadowing of the ruinous fires that would sweep through the area several years later. Disease has ravaged the wilting trees in *Live Oak in Decline, Mahomet, Texas*, 1985 (Plate 30), while the colossal stump visible through the thicket of young trees in *Redwoods, Salt Point, California*, 1974 (Plate 24) poignantly testifies to humanity's impact on the forest.

Ward has frequently photographed landscapes that are burdened with the weight of history and fame. Some of these places, such as the stunning geological formations of *Canyon de Chelly National Monument, Arizona*, 1975 (Plate 23) and *Temple of the Sun, Capitol Reef National Park, Utah*, 1984 (Plate 46) are central to the popular image of the American West as an epic frontier. Others have been immortalized through the medium of photography itself, as in *Badlands near Zabriskie Point, Death Valley National Monument, California*, 1982 (Plate 55), a mesmerizing site interpreted in unique ways by both Ansel Adams and Edward Weston. Ward describes *Desert View, Grand Canyon National Park, Arizona*, 1983 (Plate 49) as his "favorite picture of his favorite place."[19] Despite its status as one of the most photographed landscapes on earth, Ward represents this dramatic subject in an unexpected light, devoid of overwrought heroism or

cliché. Shrouded in clouds and dusted with snow, Ward's Grand Canyon is enigmatic and primal, yet brushed with a sense of communion and intimacy.

Despite his role as a witness to such remarkable scenes, Ward does not consider his work to be documentary. He describes his creative process in strictly formal terms—a delicate reconciliation between conflicting shapes, tones, and values. Ward relishes the challenge of finding balance and harmony within nature's random designs. Many of his finest works are filled with pictorial ambiguities and tension, as evident in *Henry Mountains and Waterpocket Fold, Capitol Reef National Park, Utah*, 1984 (frontispiece), where the camera has melded two separate mountains into one sweeping form. Likewise, what appears to be a cloud-filled sky in *Sunrise, Black Mountains, Death Valley National Monument, California*, 1982 (Plate 7) is actually the land itself, transformed into an ethereal horizon by Ward's imaginative handling of light.

The Wards traveled throughout the 1980s and turned their attention to several new endeavors. In 1981, Ward produced *Landscape*, a portfolio of twelve of his most important prints in an edition of fifty, which quickly sold out. Three years later, Westcliffe Publishers issued a monograph of Ward's color imagery from his home state titled *Colorado: Magnificent Wilderness*. The book has remained in print for the past twenty years. Ward's work has been featured in numerous other publications, including those of the Audubon Society, the Rocky Mountain Nature Association, and the Sierra Club.[20] In 1983 and 1984, Ward taught workshops in large-format field photography in Victor, Colorado, and was appointed William Allen White Artist in Residence at Rocky Mountain National Park in 1985 and 1987. Subsequent workshops in landscape photography followed at Crested Butte, Colorado, and the Peters Valley Craft Center in Layton, New Jersey. In 1984, Ward began his long association with The Grapevine Gallery in Oklahoma City, Oklahoma, and taped the first of three half-hour television programs for the Oklahoma City Metropolitan Library. The most memorable of these was a demonstration of the dye-transfer printing process, which, due to its rigorous technical demands and the scarcity of the necessary supplies, is now considered by many to be a lost art.[21]

From 1984 to 1989, Ward's primary work in the field, outside of Colorado, was in Texas, which he admits was a somewhat improbable choice motivated in part by the promise of a book that never came to pass. Despite these circumstances, Ward's Texas imagery constitutes some of his finest and is much less frequently depicted than the more grandiose scenery of southern Utah, another region where he has photographed extensively. Ward responded intuitively to the state's diverse geography, from the craggy West Texas terrain seen in *November Snow, Chisos Mountains, Big Bend National Park, Texas*, 1986 (Plate 57) to the verdant East Texas greenery of *Live Oak and Spanish Moss, Brazos Bend State Park, Texas*, 1986 (Plate 44). One image of particular significance to Ward is *Terlingua, Texas*, 1984 (Plate 31), taken on his first trip into the Chihuahuan Desert and, unknowingly, on the very day—April 22, 1984—that Ansel Adams died. Ward normally refrains from physically altering the natural state of his subjects, but coincidentally, in this instance

he allowed Susan to prop up a broken wooden cross found beside the building's loggia, a seemingly modest change to the stoic ruin that made a profound difference in the photograph.

By the late 1980s, the Wards were spending less time in the field and more time working on projects at their home in Boulder. In 1988, they founded Camerata Publishing to produce an annual picture calendar of nearby Rocky Mountain National Park, which has been Ward's primary muse since the late 1960s. Shortly thereafter, through the efforts of Denver collector Paul Harbaugh, Ward was invited by the Latvian Photographic Arts Society to show his work in Riga, Latvia. Ward assembled a retrospective exhibition comprising ninety of his finest 16-by-20-inch gelatin silver prints, which spanned the years between 1969 and 1987. The exhibition took place during the chaotic days of 1991 as the Soviet Union was breaking apart and the small Baltic republic was pursuing a course of independence and democracy. It was a remarkable if unanticipated backdrop for Ward's photographs of the American West. After the exhibition returned to Colorado, Ward, inspired by Eliot Porter's gift of his *Antarctica* portfolio years earlier, gave all ninety prints to James Haines, a collector and longtime friend. With Ward's blessing, Haines looked for an institutional home for the photographs, and in 1997 he donated the entire body of work to the El Paso Museum of Art.

In 1994, the Wards moved to a house on Prospect Mountain in Estes Park, Colorado, the scenic entrance to Rocky Mountain National Park, where John built and outfitted his finest darkroom to date. Their understated home is filled with books and classical music as well as photographs and pottery by both Wards and other artists the couple admire. Ward continues to reinterpret past work from his archive while upholding the highest standards for his prints. He has never utilized darkroom assistants or turned his negatives over to another printer. In recent years, Ward, like every photographer, has had to come to terms with the torrid pace of technological change that is transforming the medium from day to day. He has expanded his technical prowess far into the digital realm with the same verve and intellectual rigor that fueled his initial exploration of photography. At the same time, Ward remains steadfastly committed to the tradition of the large-format view camera and to discovering the poetry in land and light.

—*William R. Thompson*

NOTES

1. Unless otherwise noted the information in this essay is based on a series of interviews with John and Susan Ward conducted by the author in 2002–3.

2. John Ward, letter to the author, October 23, 2000.

3. John Ward, *Colorado: Magnificent Wilderness* (Englewood, Colo.: Westcliffe, 1984), 8.

4. Mary Street Alinder, *Ansel Adams: A Biography* (New York: Henry Holt, 1996), 260–98.

5. Ward owned and studied volumes 2–5 of Adams's *Basic Photo Series*, as well as several other publications by and about the artist, including Ansel Adams and Nancy Newhall, *This Is the American Earth* (San Francisco: Sierra Club, 1960); Ansel Adams, *These We Inherit: The Parklands of America* (San Francisco: Sierra Club, 1962); and Nancy Newhall, *Ansel Adams Volume I: The Eloquent Light* (San Francisco: Sierra Club, 1963).

6. John Rohrbach, "Envisioning the World in Color," in *Eliot Porter: The Color of Wildness* (New York: Aperture; Fort Worth: Amon Carter Museum, 2001), 91–111.

7. See Ansel Adams, *Portfolio Three: Yosemite Valley* (San Francisco: Sierra Club, 1960); Ansel Adams, *Portfolio Four: What Majestic Word, In Memory of Russell Varian* (San Francisco: Sierra Club, 1963); and Eliot Porter, *Portfolio One: The Seasons* (San Francisco: Sierra Club, 1964). These portfolios are currently housed in the Special Collections Department at Norlin Library at the University of Colorado at Boulder. There is no record of when or how they were originally acquired.

8. John Frederick Ward, "Correlation Effects in the Theory of Combined Doppler and Pressure Broadening" (Ph.D. diss., University of Colorado, 1971), v.

9. Ward's dissertation was a theoretical study of how light radiates from atoms in a gas.

10. The Center for Creative Photography was established with the archives of photographers Ansel Adams, Wynn Bullock, Harry Callahan, Aaron Siskind, and Frederick Sommer.

11. Ward was featured along with portrait photographer Mary Simonsen.

12. The exhibition was on view from October 6 to November 4, 1973. See Beaumont Newhall, *Southwestern Photography Exhibition 1973* (Dallas: Dallas Museum of Fine Arts, 1973). *Black Rock, Olympic Coast, Washington* was then titled *Rock Detail, Rialto Beach, Olympic National Park* and was listed as #102 in the exhibition checklist.

13. See Jim Bones Jr. and John Graves, *Texas Heartland: A Hill Country Year* (College Station: Texas A&M University Press, 1975).

14. *Eliot Porter Retrospective* was on view at the University of New Mexico Art Museum from March 20 to April 15, 1973, before traveling to a number of other venues.

15. See Eliot Porter, *Antarctica* (New York: E. P. Dutton, 1978).

16. See Laura Gilpin, *The Pueblos: A Camera Chronicle* (New York: Hastings Howe, 1941), 65; and Martha A. Sandweis, *Laura Gilpin: An Enduring Grace* (Fort Worth: Amon Carter Museum, 1986), plate 94.

17. The Wards' journals document more than fifty camping trips between 1974 and 1988.

18. "John Ward: The Western Landscape, in the Classic Tradition," *Photography Annual* (1981): 116–23, 158.

19. Ward, letter to the author, October 23, 2000.

20. Ward has contributed images to calendars published by the Audubon Society and to books such as John C. Emerick, *Rocky Mountain National Park Natural History Handbook* (Niwot, Colo.: Roberts Rinehart, 1995), and Tom Turner, *Sierra Club: 100 Years of Protecting Nature* (New York: Harry N. Abrams, 1991).

21. "Dye Transfer Photography with John Ward," Creative Crafts #8612 (KTVY–Oklahoma City/Metropolitan Library System's Community Workshop), November 3, 1986, 28 minutes, 25 seconds, hosted by Dan Blanchard. Kodak discontinued the production and sale of dye-transfer materials in 1994.

LIST OF PLATES

Frontispiece: Henry Mountains and Waterpocket Fold, Capitol Reef National Park, Utah, 1984

1. Yellowstone Lake, Yellowstone National Park, Wyoming, 1982
2. Saguaros and Ajo Mountains, Organ Pipe Cactus National Monument, Arizona, 1978
3. North Clear Creek Falls, Rio Grande National Forest, Colorado, 1977
4. Tree in Fog, Olympic Coast, Washington, 1972
5. Sand Dunes No. 3, Death Valley National Monument, California, 1982
6. Mummy Range in Clouds, Rocky Mountain National Park, Colorado, 1987
7. Sunrise, Black Mountains, Death Valley National Monument, California, 1982
8. Bentonite Hills, Capitol Reef National Park, Utah, 1984
9. Black Rock, Olympic Coast, Washington, 1972
10. Corner Shadows, Church at San Ildefonso, New Mexico, 1974
11. Window and Screen, Mineral Point, Colorado, 1979
12. Broken Board, Victor, Colorado, 1984
13. Window, Rhyolite, Nevada, 1982
14. Rock, Salt Point, California, 1974
15. Bentonite Hills, Caineville Wash, Utah, 1984
16. Lewis Lake, Medicine Bow National Forest, Wyoming, 1982
17. Mills Lake, Rocky Mountain National Park, Colorado, 1969
18. Clouds and Range near Craig, Colorado, 1982
19. Mist at Ouzel Falls, Rocky Mountain National Park, Colorado, 1970
20. Stream and Logs, Mount Rainier National Park, Washington, 1972
21. Sandstone Wall, Upper Muley Twist Canyon, Capitol Reef National Park, Utah, 1984
22. Wingate Wall, Long Canyon, Utah, 1984
23. Canyon de Chelly National Monument, Arizona, 1975
24. Redwoods, Salt Point, California, 1974

25. Black Sand Basin, Yellowstone National Park, Wyoming, 1982

26. Trees on Dune, Great Sand Dunes National Monument, Colorado, 1976

27. El Morro National Monument, New Mexico, 1975

28. Vineyard, Borrego Springs, California, 1979

29. Dos Cabezas, Arizona, 1978

30. Live Oak in Decline, Mahomet, Texas, 1985

31. Terlingua, Texas, 1984

32. Kent Public School, Texas, 1985

33. Matfield Green Elementary School, Kansas, 1985

34. Caffery Building, Victor, Colorado, 1983

35. Two Windows, Victor, Colorado, 1983

36. Old La Veta Pass Motel, Colorado, 1981

37. First Church of Christ Scientist, Victor, Colorado, 1983

38. Boarded Building, Victor, Colorado, 1983

39. Betatakin Cave, Navajo National Monument, Arizona, 1974

40. Rico, Colorado, 1976

41. Water Tower Karst, Death Valley National Monument, California, 1982

42. Rust and Metal, Argo Mill, Idaho Springs, Colorado, 1974

43. Saguaro Cactus Detail, Arizona, 1978

44. Live Oak and Spanish Moss, Brazos Bend State Park, Texas, 1986

45. Cottonwoods, Capitol Reef National Park, Utah, 1979

46. Temple of the Sun, Capitol Reef National Park, Utah, 1984

47. Fin, Arches National Park, Utah, 1972

48. Sangre de Cristo Range, Colorado, 1976

49. Desert View, Grand Canyon National Park, Arizona, 1983

50. Spring Snow, Boulder Mountain Parks, Colorado, 1973

51. Forest, Palmetto State Park, Texas, 1986

52. Lower Falls in Winter, Bandelier National Monument, New Mexico, 1975

53. Pine Bark, Caddo Lake State Park, Texas, 1986

54. Grotto, McKittrick Canyon, Guadalupe Mountains National Park, Texas, 1984

55. Badlands near Zabriskie Point, Death Valley National Monument, California, 1982

56. Twigs and Snow, Boulder Mountain Parks, Colorado, 1979

57. November Snow, Chisos Mountains, Big Bend National Park, Texas, 1986

58. Sharkstooth, Rocky Mountain National Park, Colorado, 1978

59. Winter Storm, Colorado National Monument, Colorado, 1973

LAND AND LIGHT IN THE AMERICAN WEST

1. Yellowstone Lake, Yellowstone National Park, Wyoming, 1982

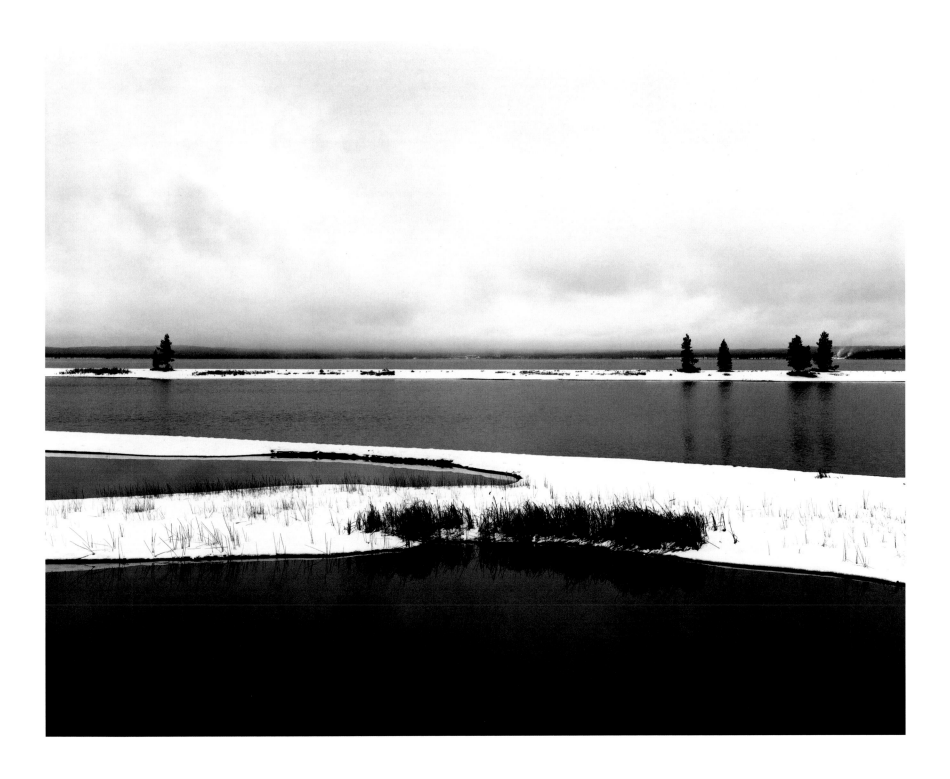

2. Saguaros and Ajo Mountains, Organ Pipe Cactus National Monument, Arizona, 1978

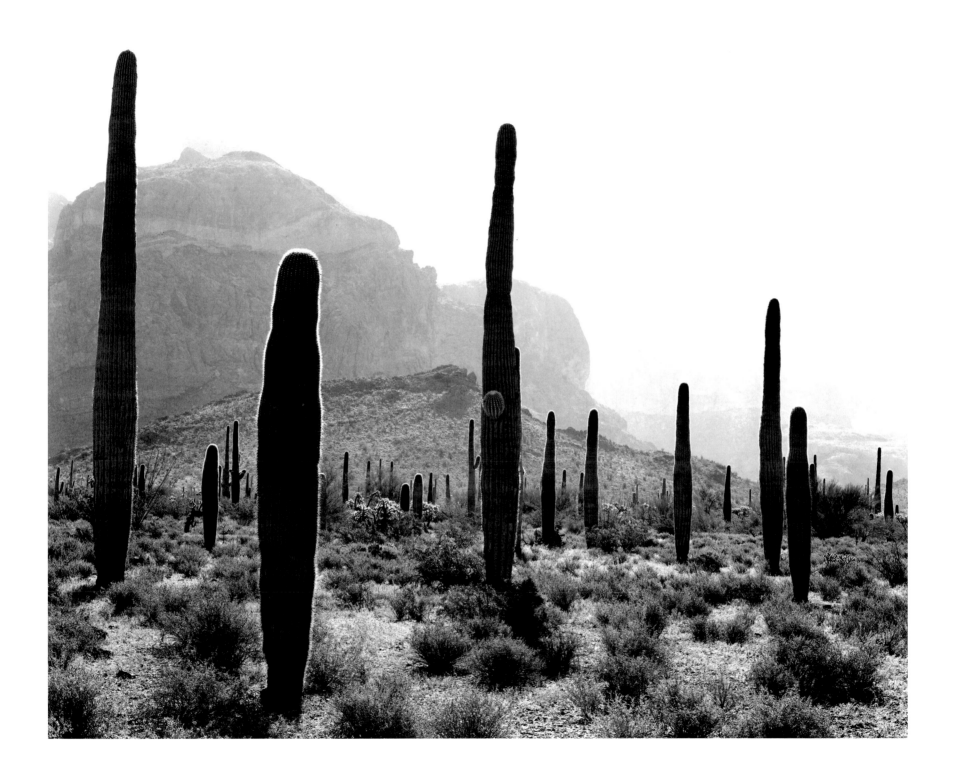

3. North Clear Creek Falls, Rio Grande National Forest, Colorado, 1977

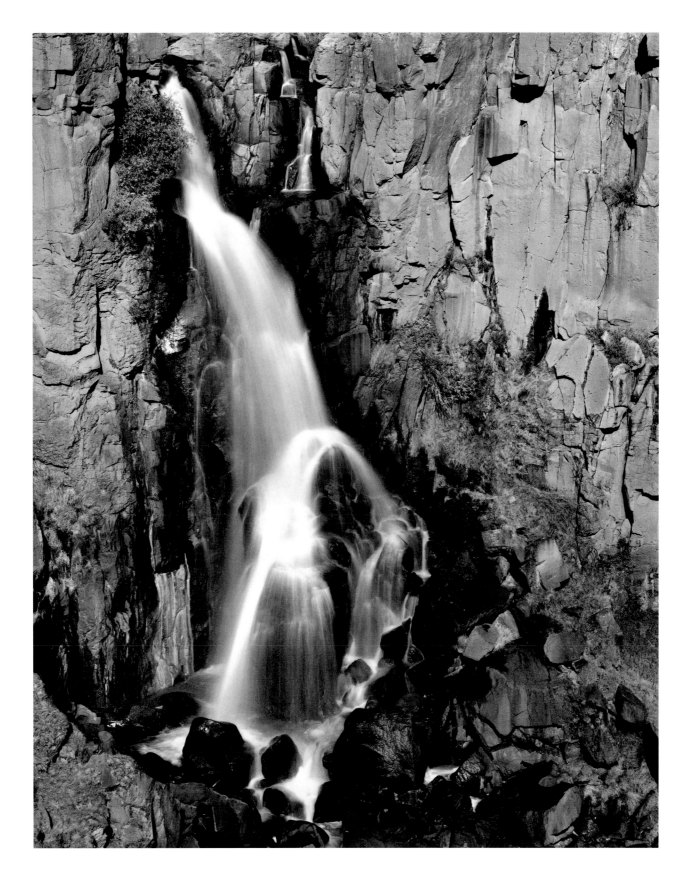

4. Tree in Fog, Olympic Coast, Washington, 1972

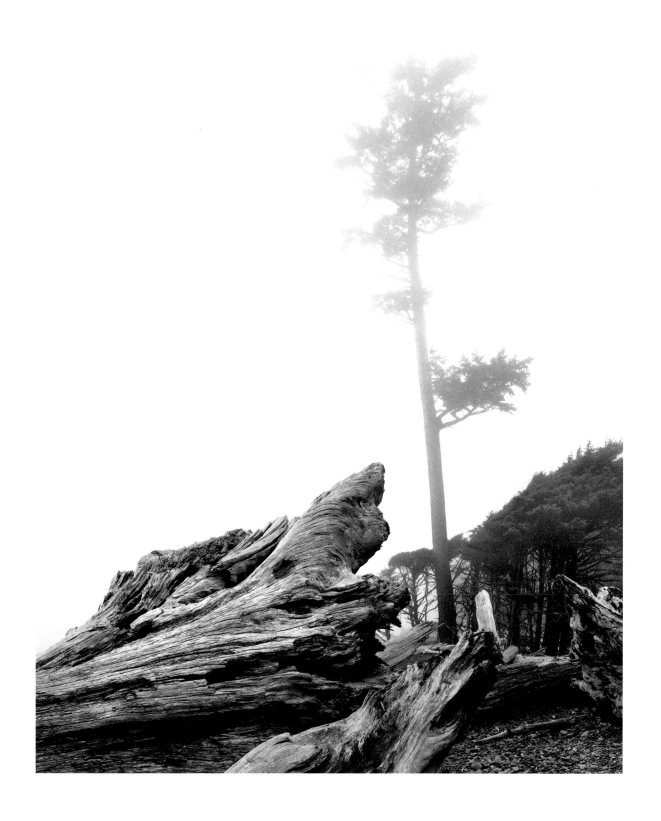

5. Sand Dunes No. 3, Death Valley National Monument, California, 1982

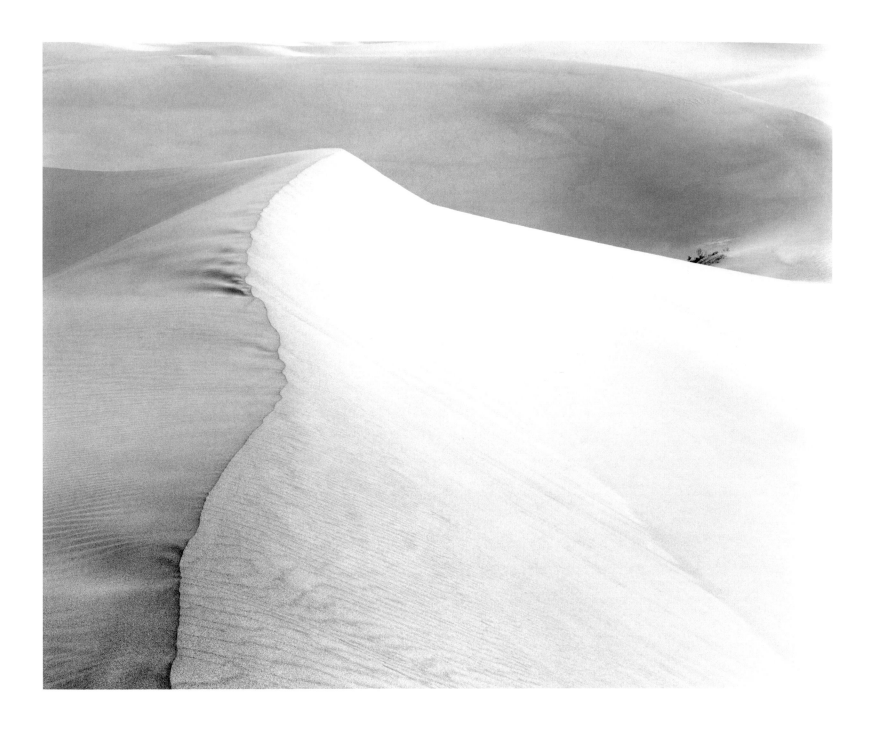

6. Mummy Range in Clouds, Rocky Mountain National Park, Colorado, 1987

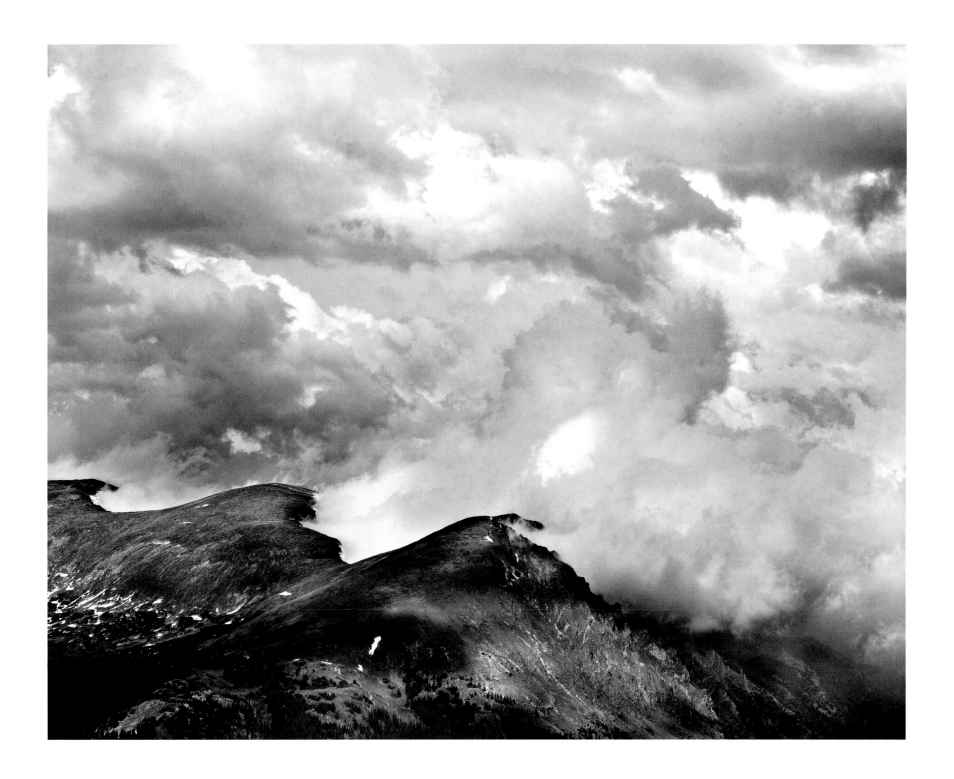

7. Sunrise, Black Mountains, Death Valley National Monument, California, 1982

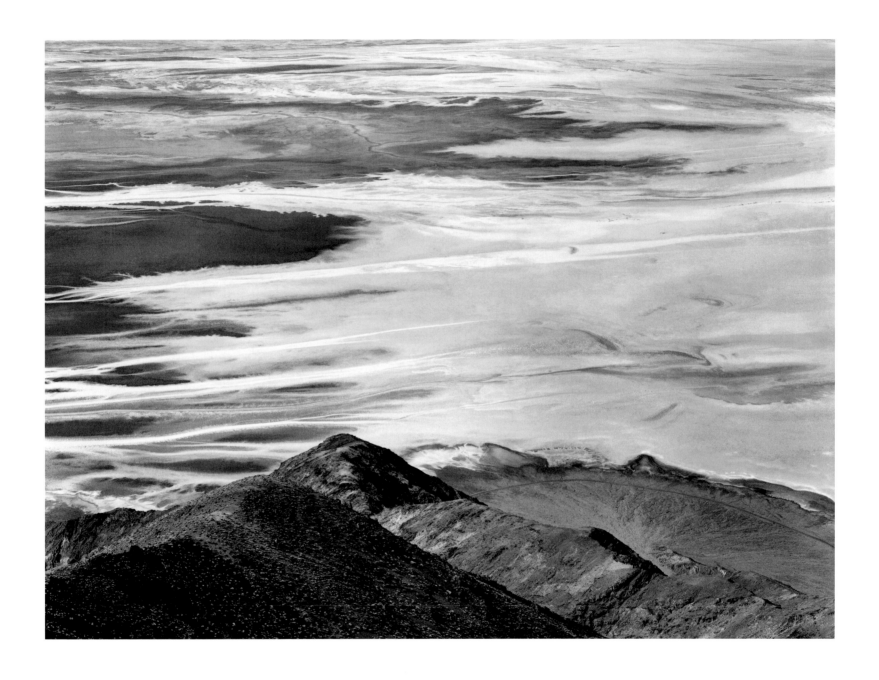

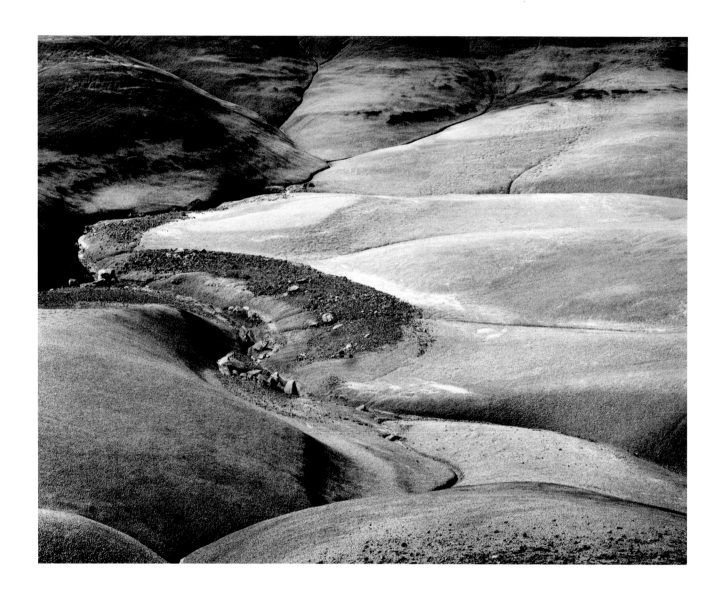

8. Bentonite Hills, Capitol Reef National Park, Utah, 1984

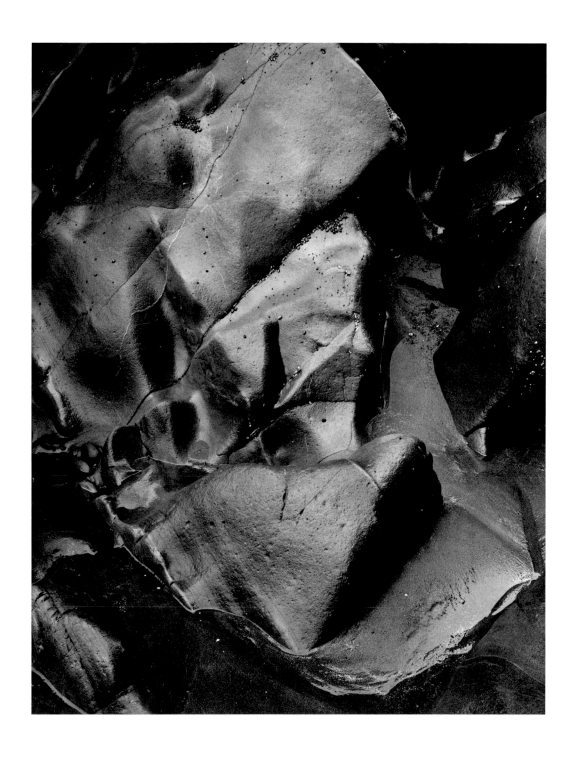

9. Black Rock, Olympic Coast, Washington, 1972

10. Corner Shadows, Church at San Ildefonso, New Mexico, 1974

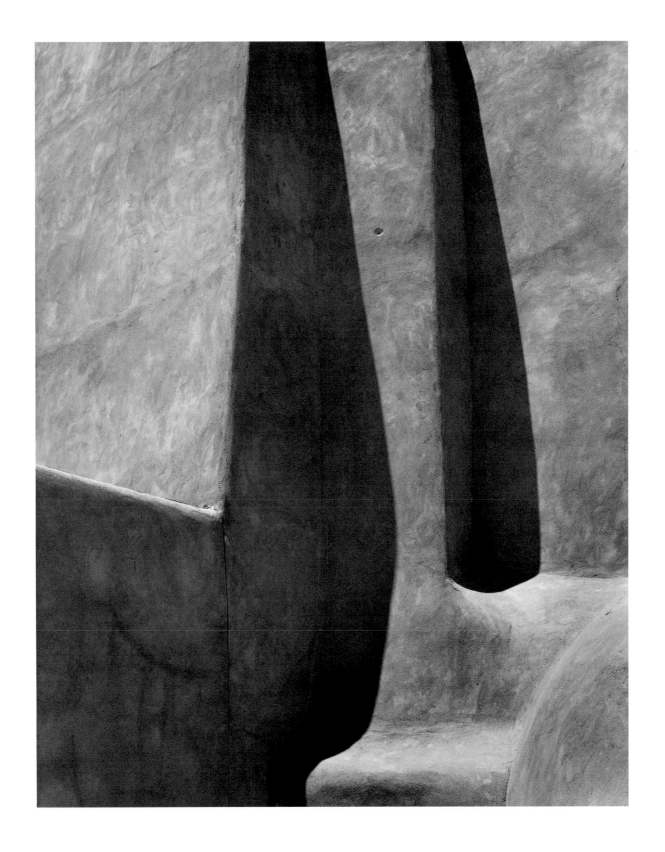

11. Window and Screen, Mineral Point, Colorado, 1979

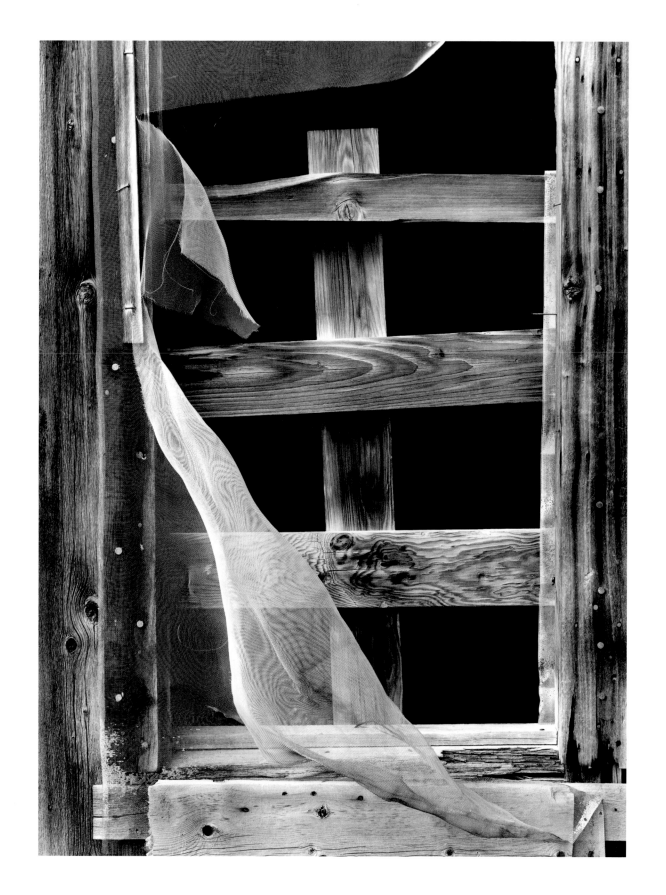

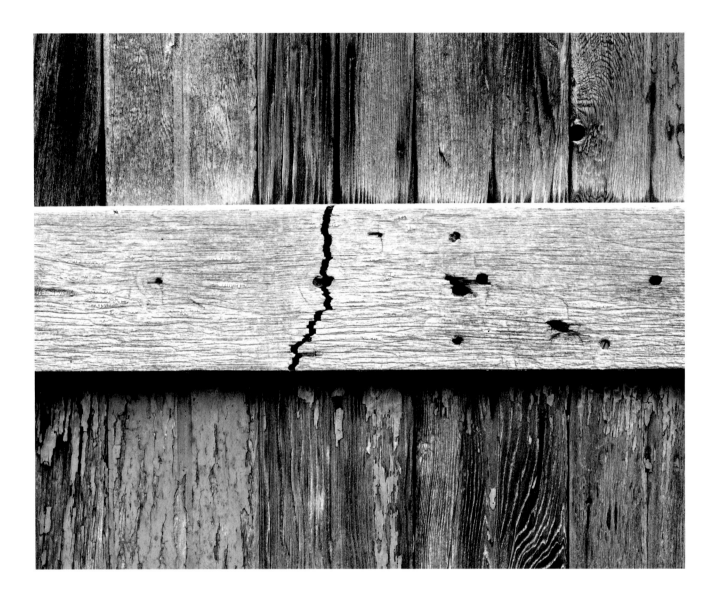

12. Broken Board, Victor, Colorado, 1984

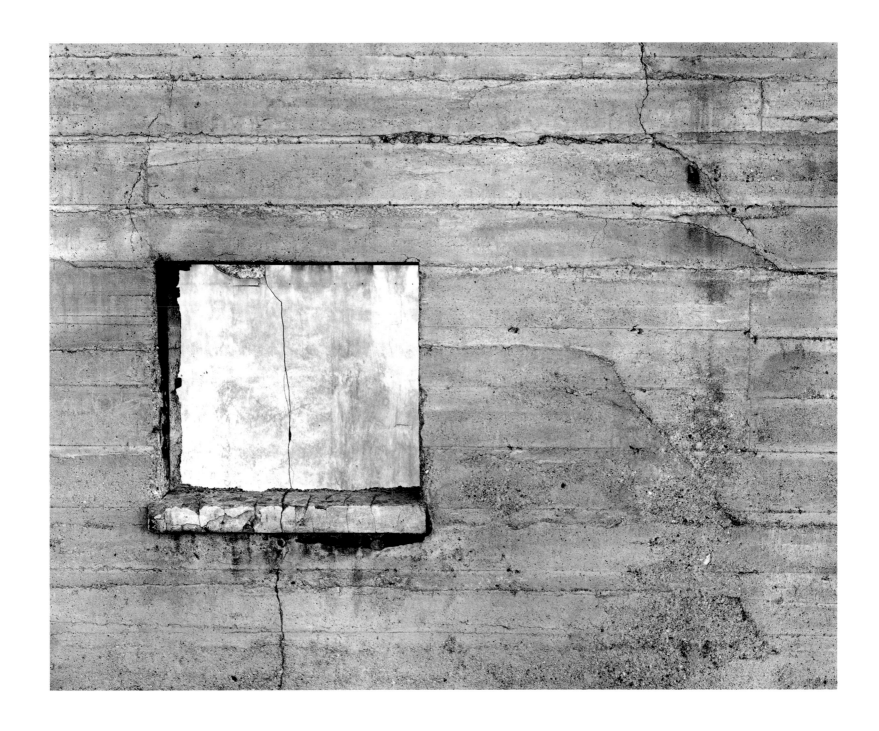

13. Window, Rhyolite, Nevada, 1982

14. Rock, Salt Point, California, 1974

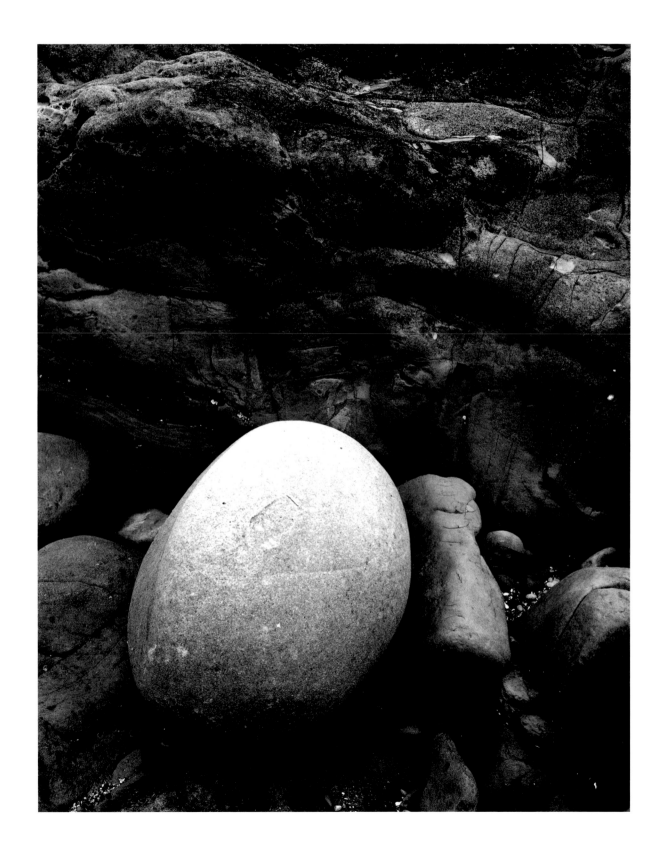

15. Bentonite Hills, Caineville Wash, Utah, 1984

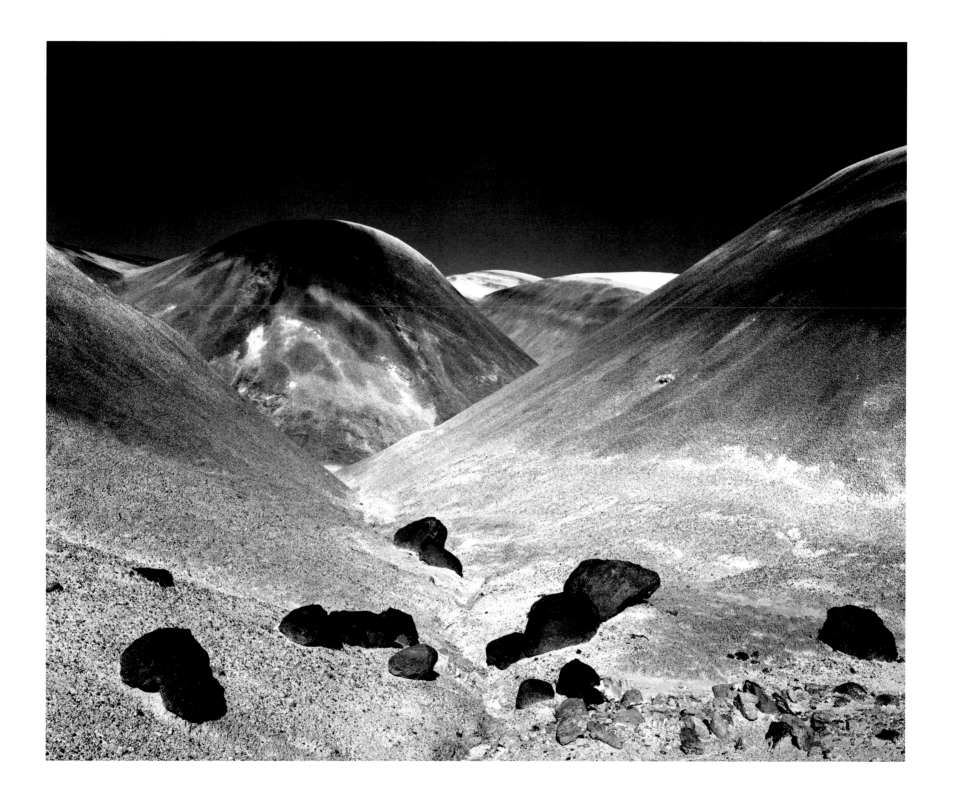

16. Lewis Lake, Medicine Bow National Forest, Wyoming, 1982

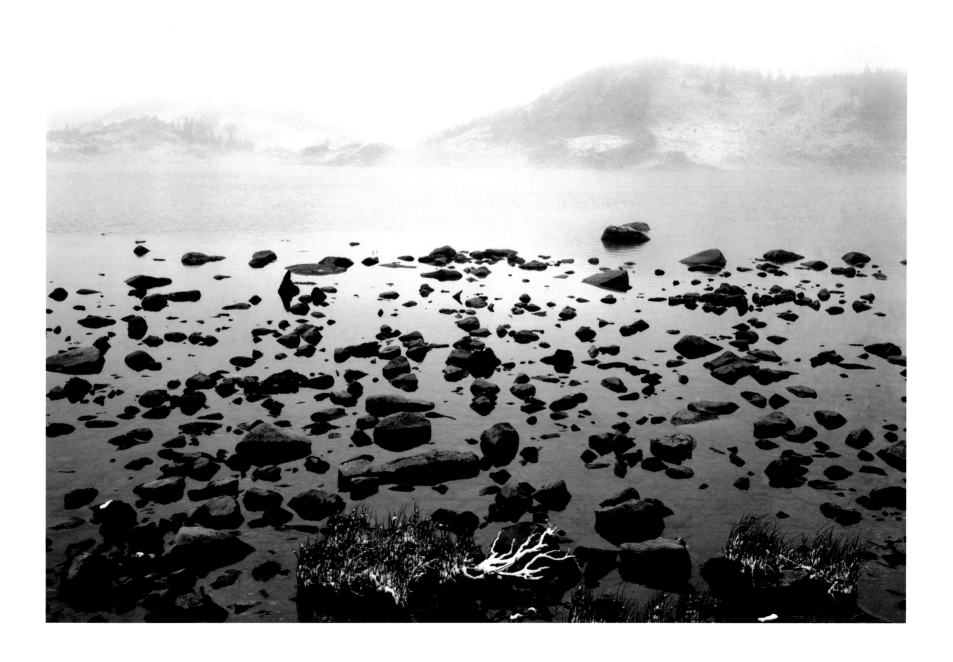

17. Mills Lake, Rocky Mountain National Park, Colorado, 1969

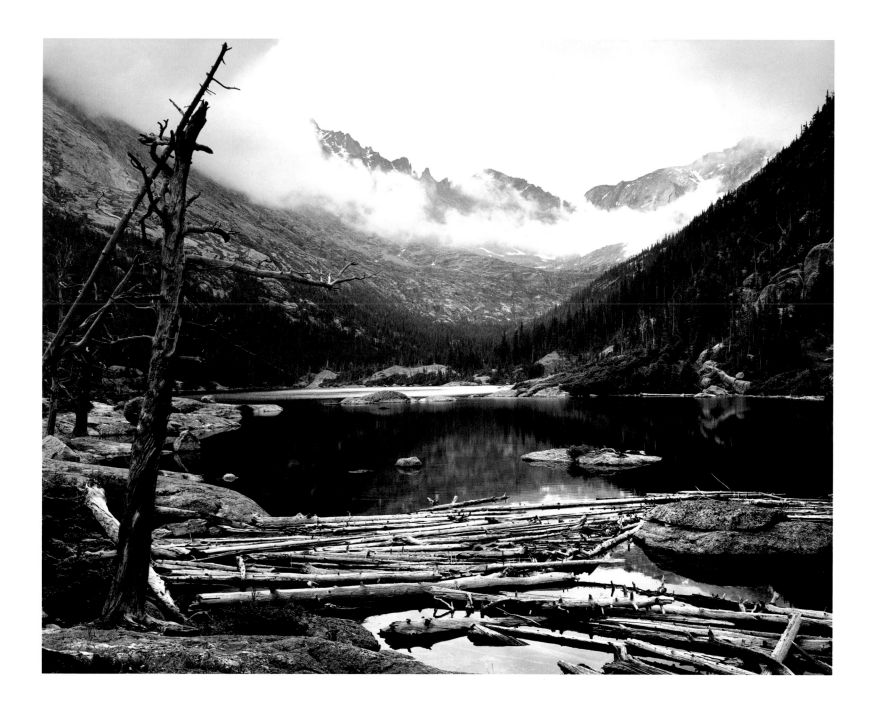

18. Clouds and Range near Craig, Colorado, 1982

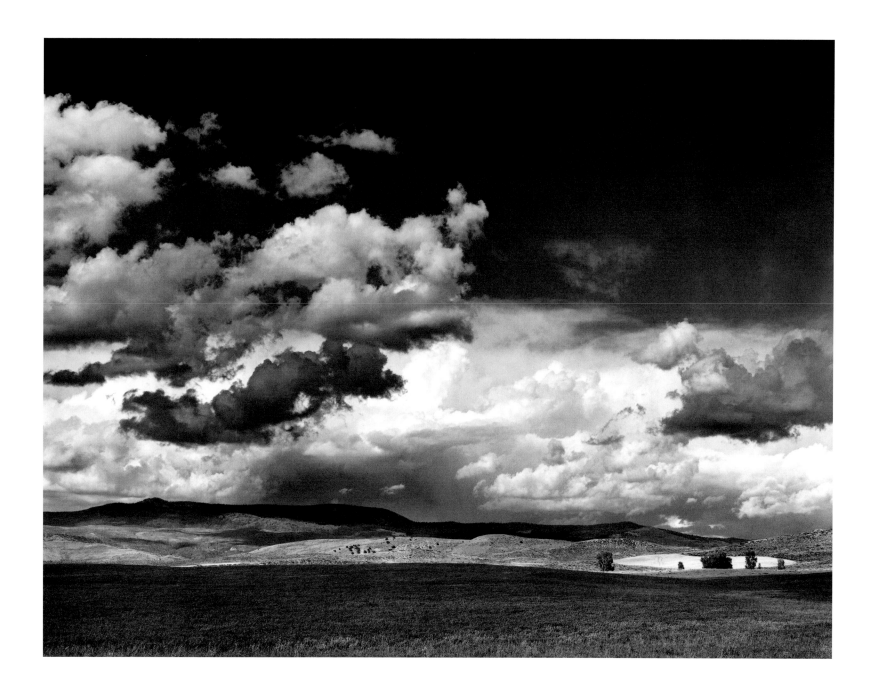

19. Mist at Ouzel Falls, Rocky Mountain National Park, Colorado, 1970

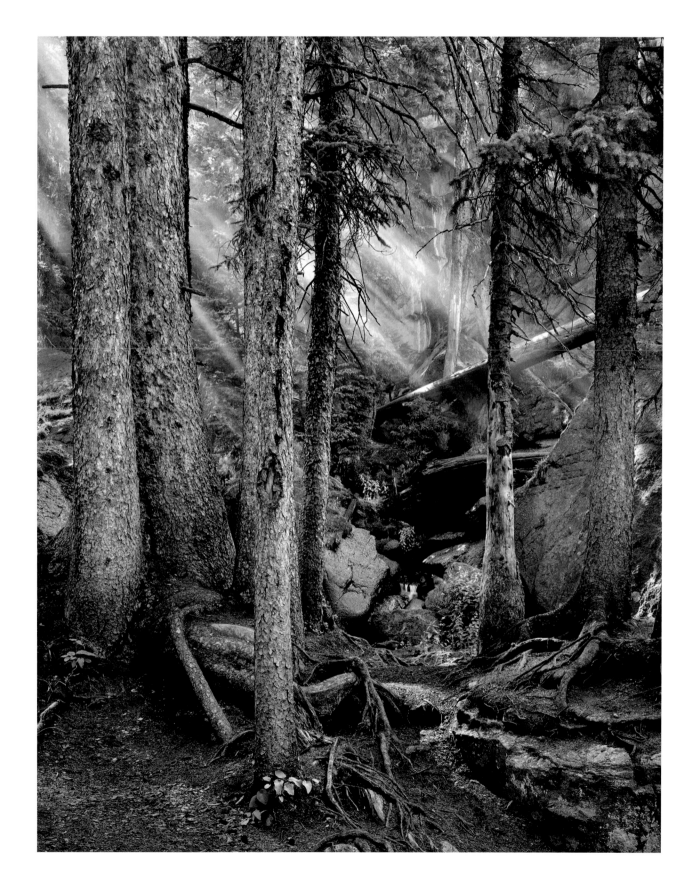

20. Stream and Logs, Mount Rainier National Park, Washington, 1972

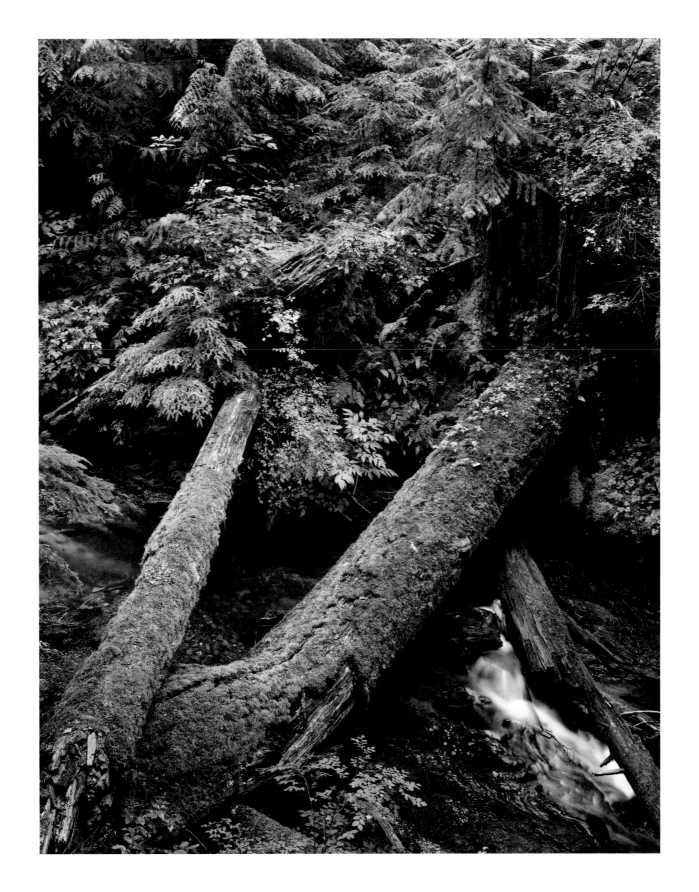

21. Sandstone Wall, Upper Muley Twist Canyon, Capitol Reef National Park, Utah, 1984

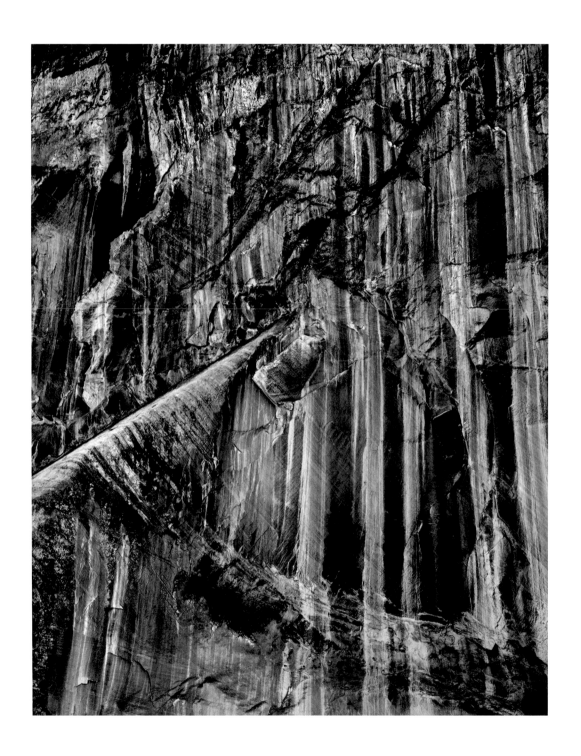

22. Wingate Wall, Long Canyon, Utah, 1984

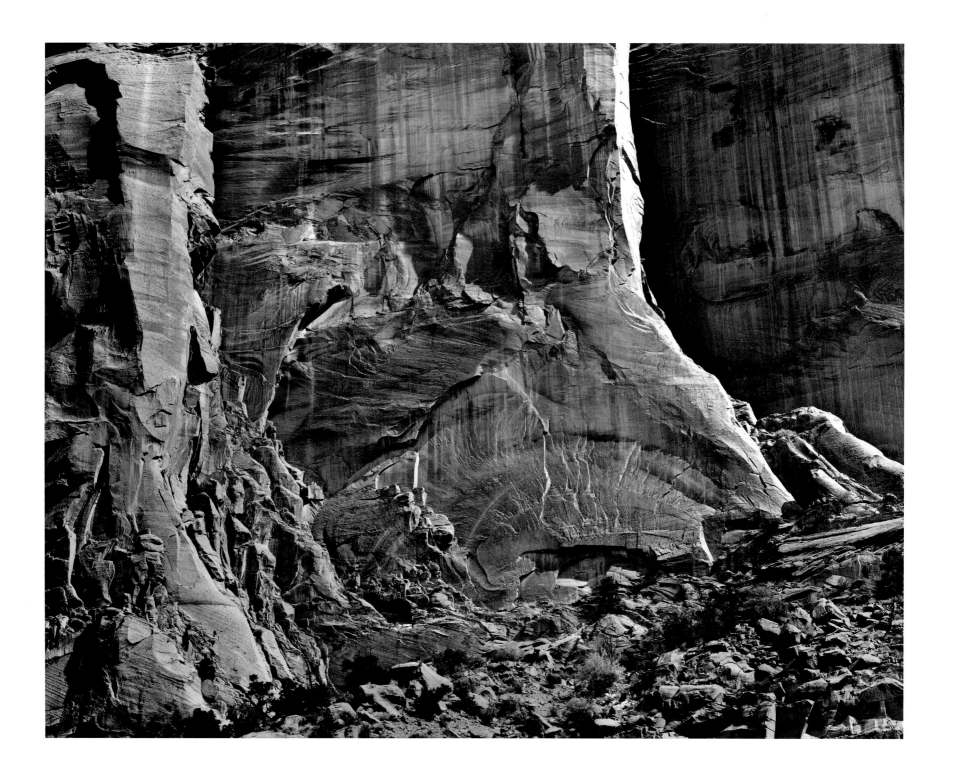

23. Canyon de Chelly National Monument, Arizona, 1975

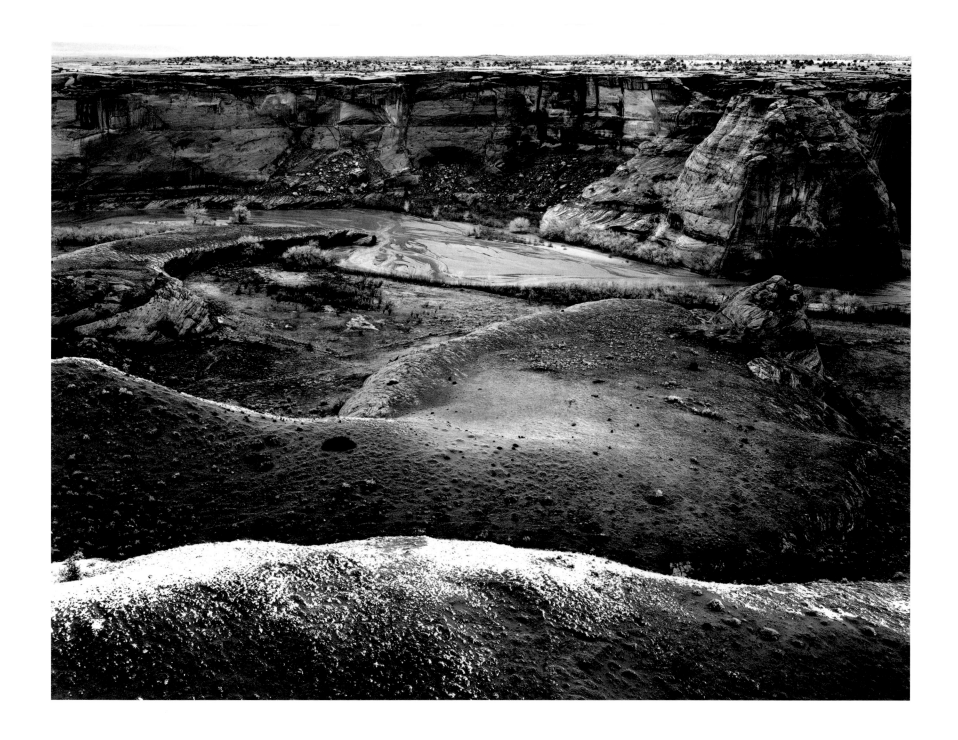

24. Redwoods, Salt Point, California, 1974

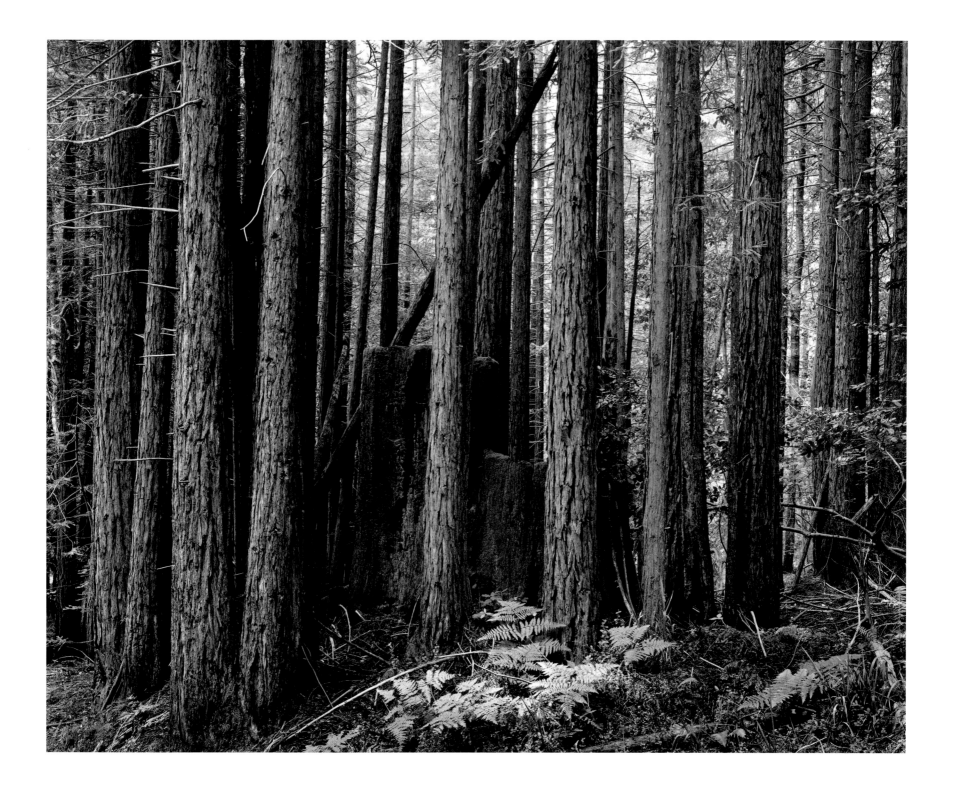

25. Black Sand Basin, Yellowstone National Park, Wyoming, 1982

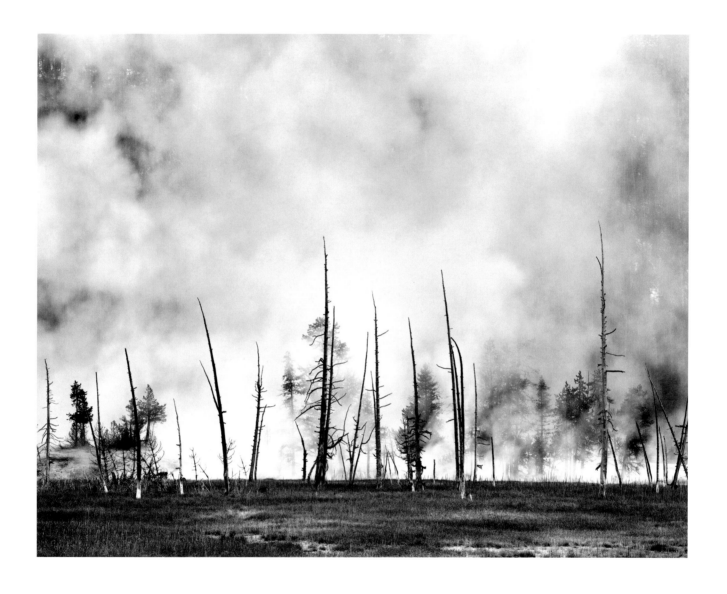

26. Trees on Dune, Great Sand Dunes National Monument, Colorado, 1976

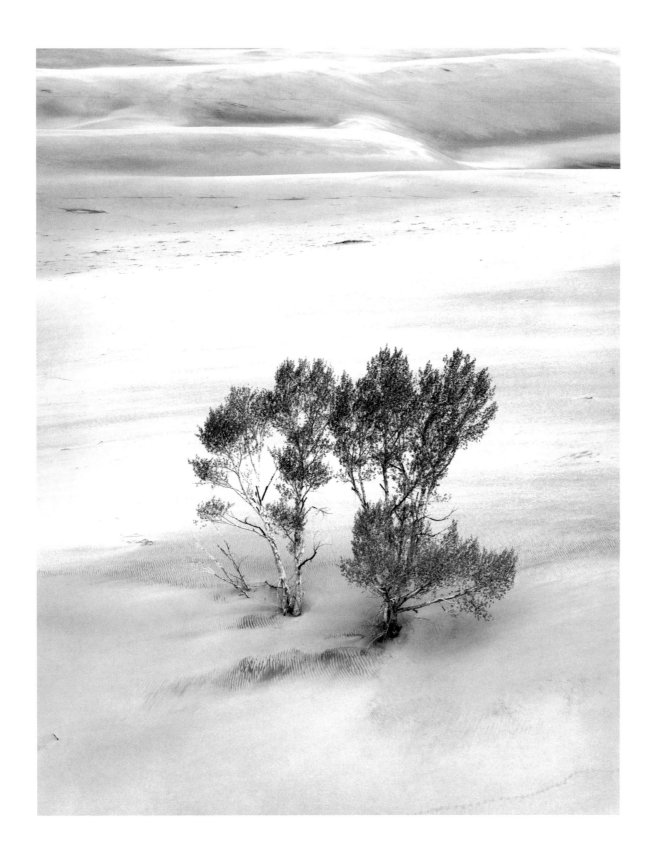

27. El Morro National Monument, New Mexico, 1975

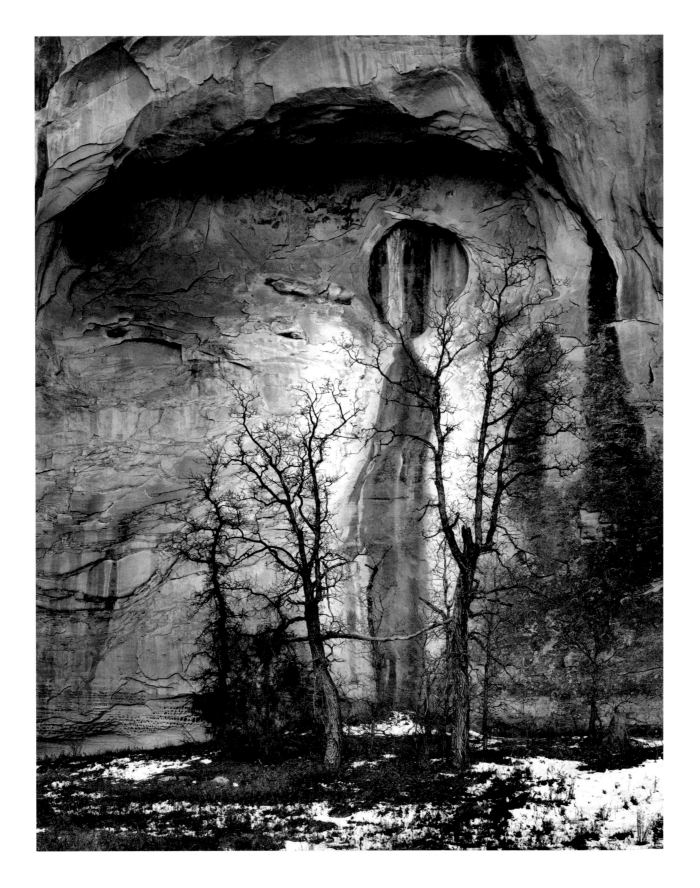

28. Vineyard, Borrego Springs, California, 1979

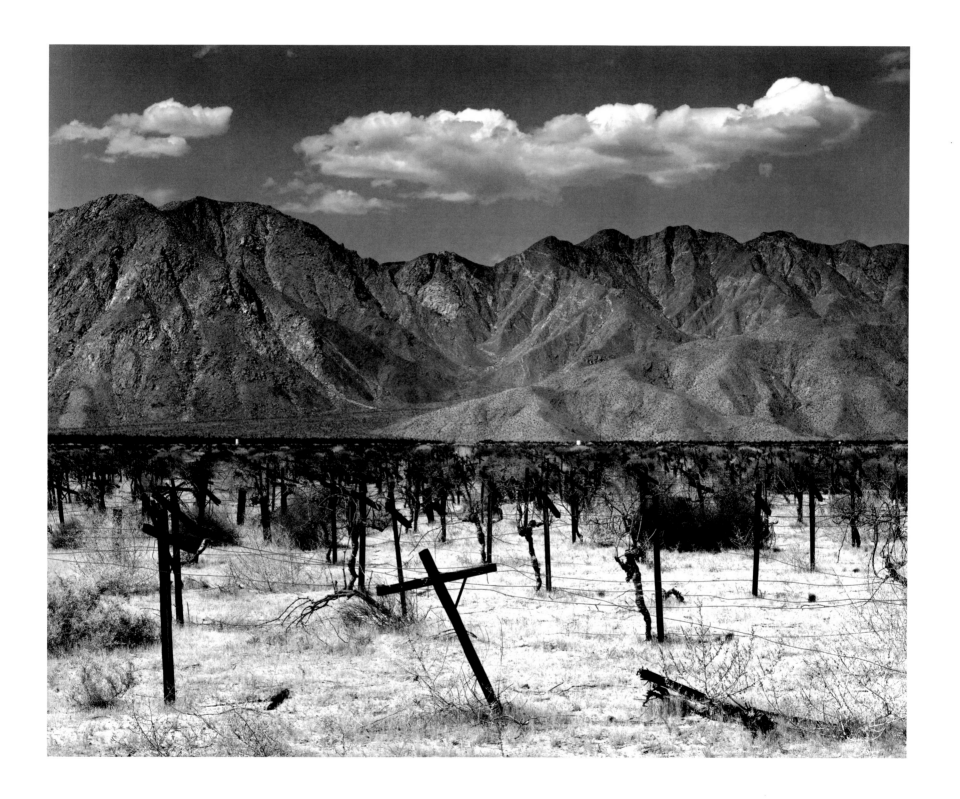

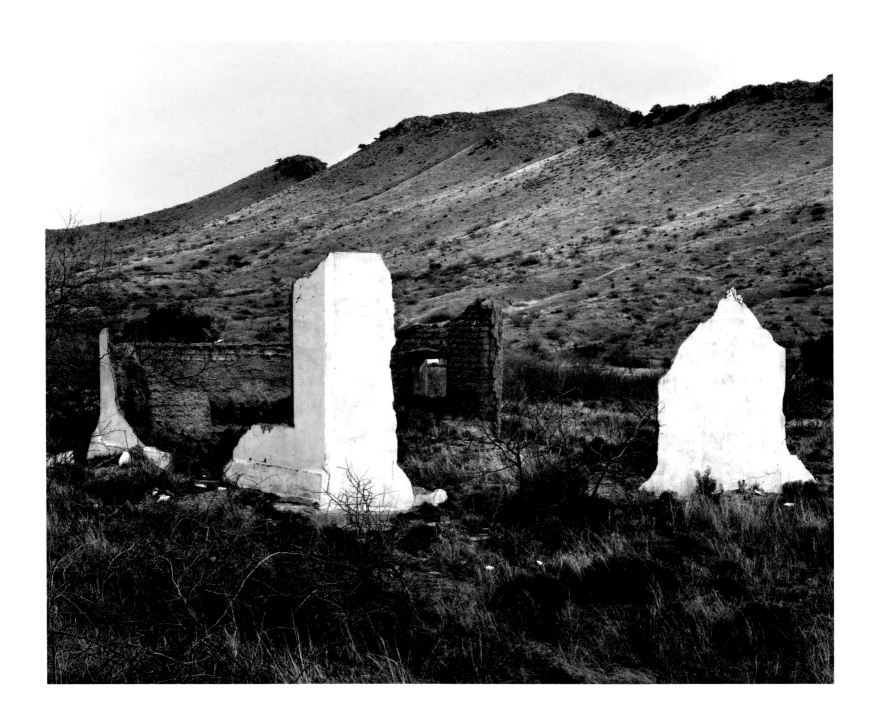

29. Dos Cabezas, Arizona, 1978

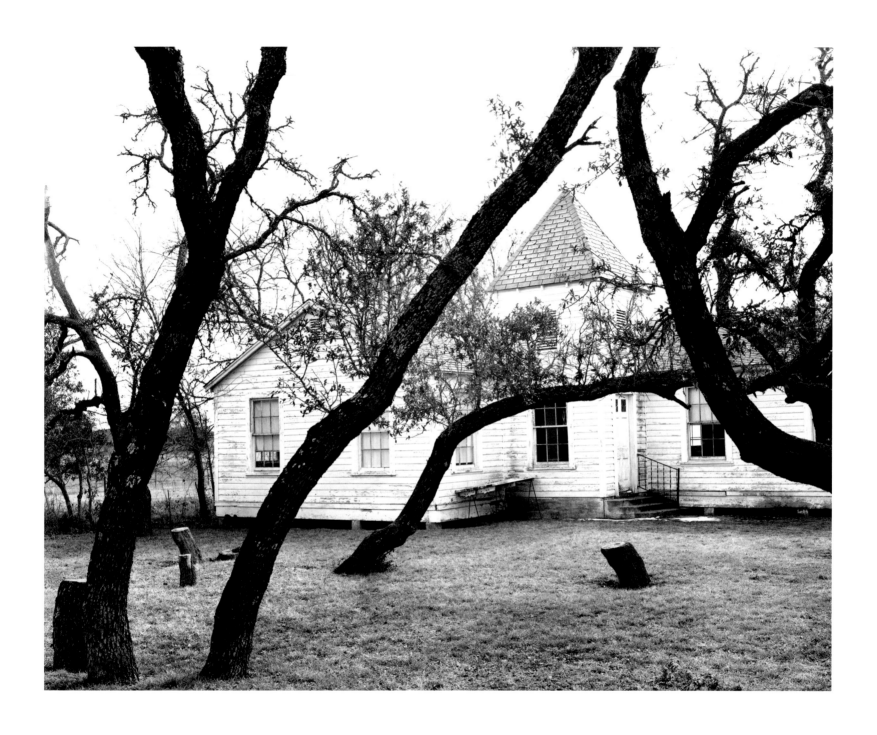

30. Live Oak in Decline, Mahomet, Texas, 1985

31. Terlingua, Texas, 1984

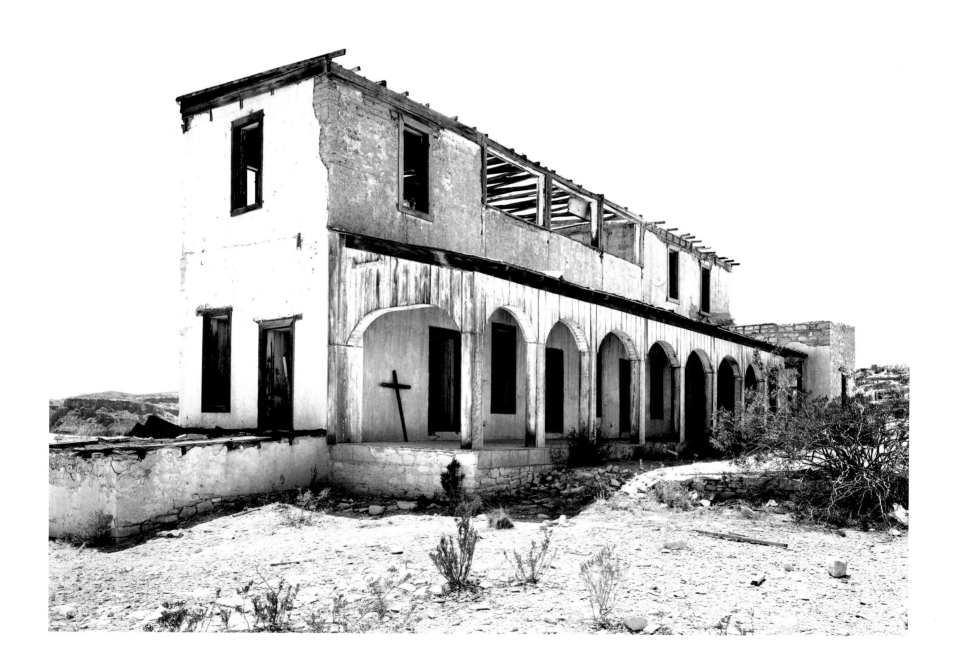

32. Kent Public School, Texas, 1985

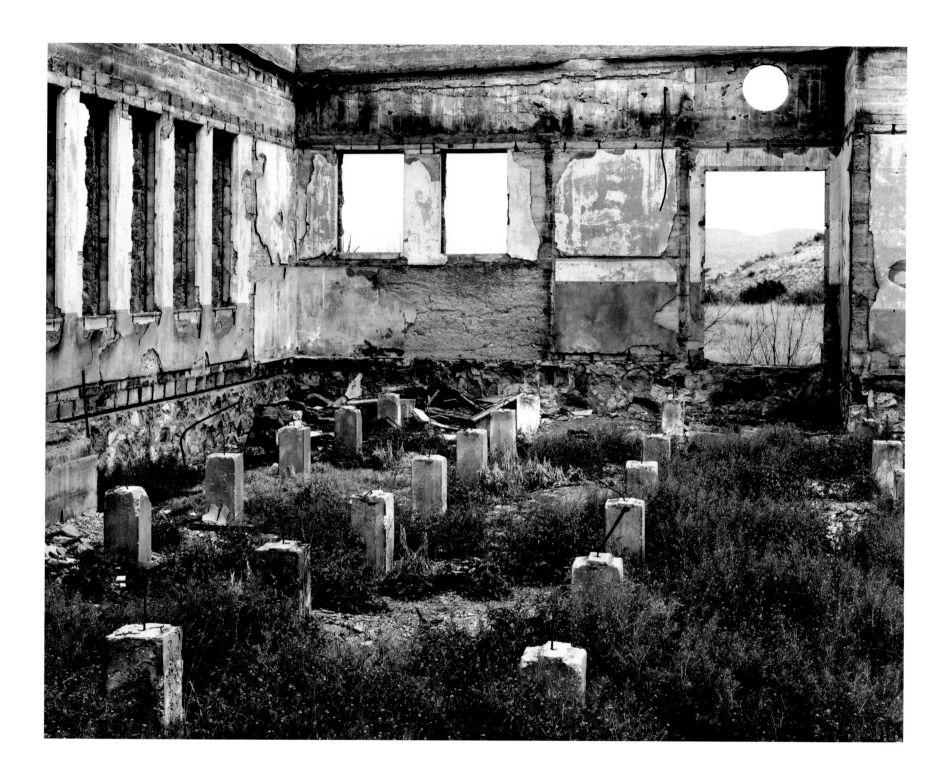

33. Matfield Green Elementary School, Kansas, 1985

34. Caffery Building, Victor, Colorado, 1983

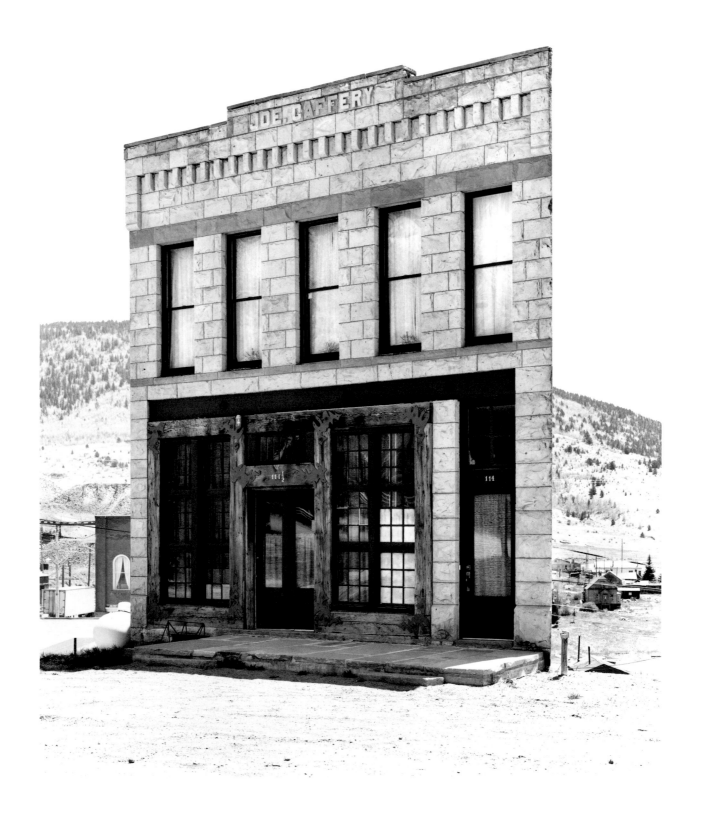

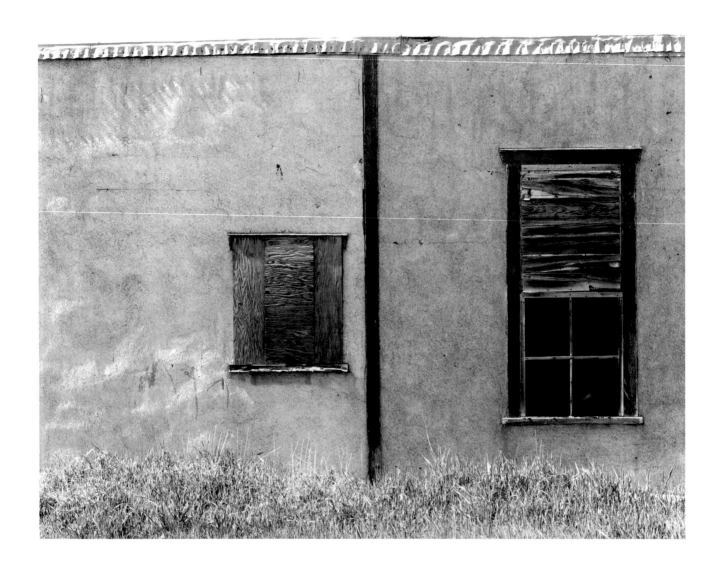

35. Two Windows, Victor, Colorado, 1983

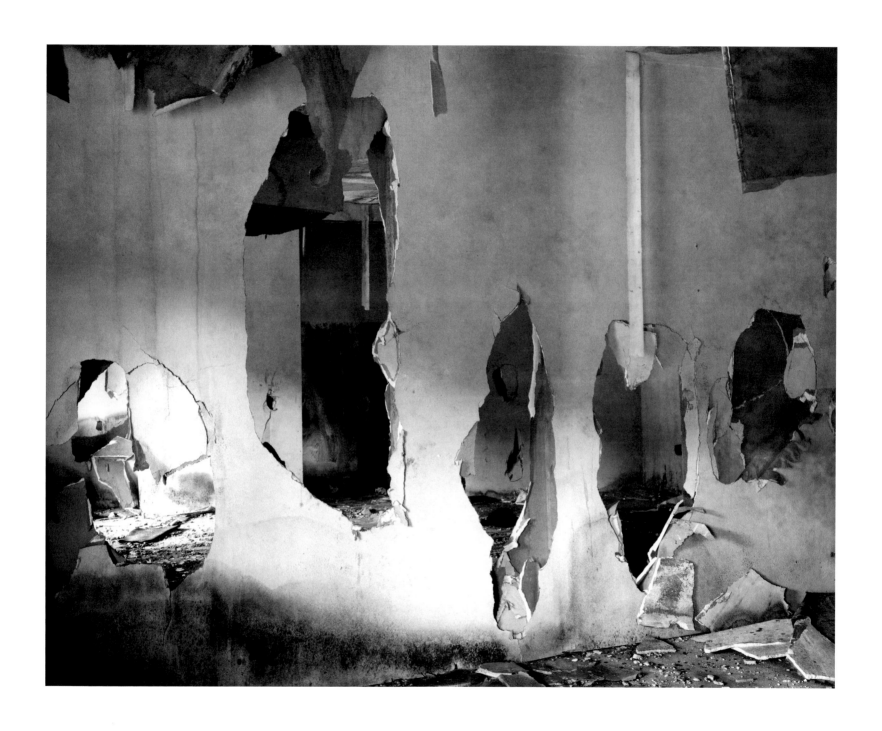

36. Old La Veta Pass Motel, Colorado, 1981

37. First Church of Christ Scientist, Victor, Colorado, 1983

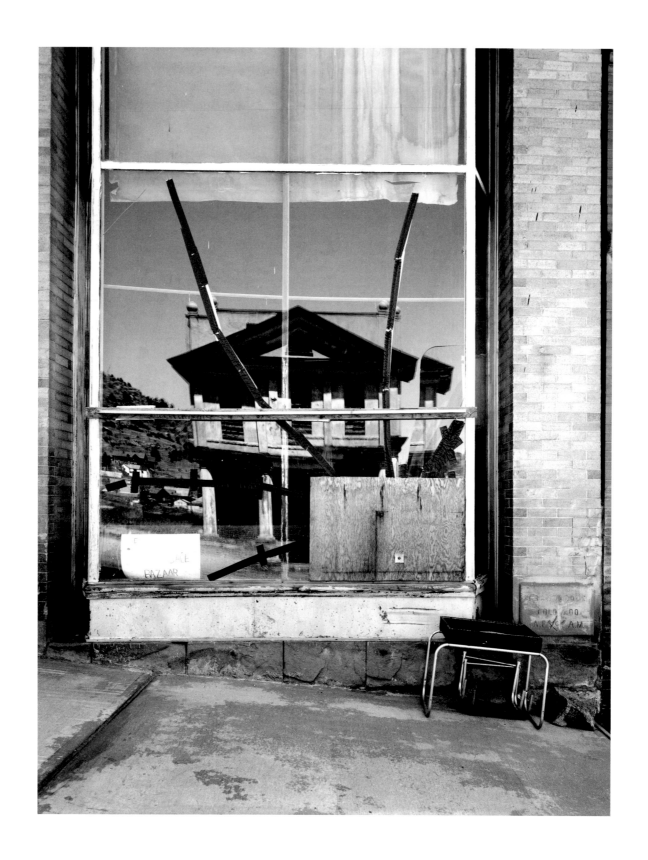

38. Boarded Building, Victor, Colorado, 1983

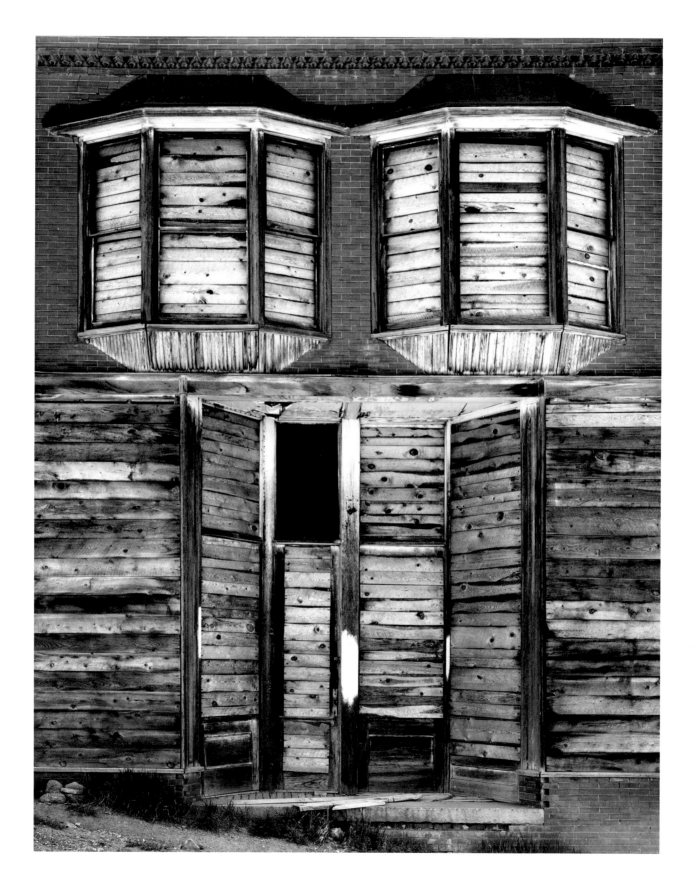

39. Betatakin Cave, Navajo National Monument, Arizona, 1974

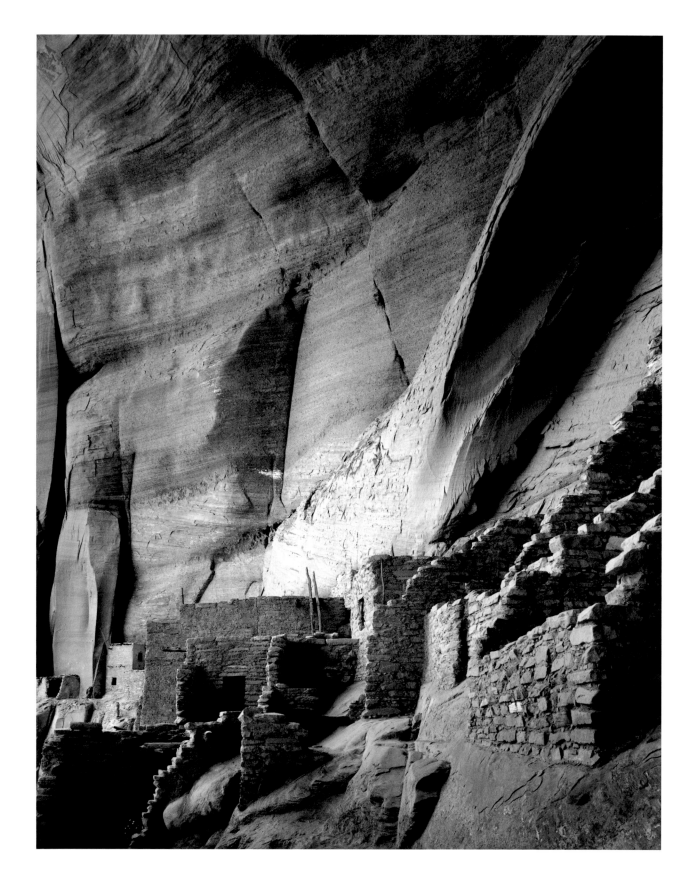

40. Rico, Colorado, 1976

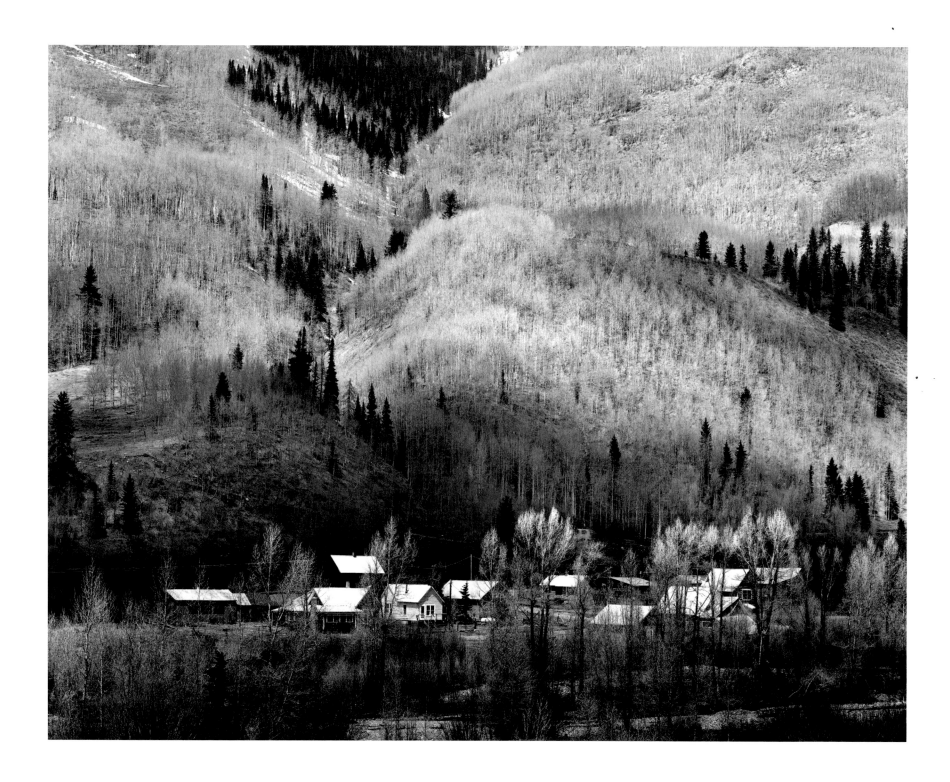

41. Water Tower Karst, Death Valley National Monument, California, 1982

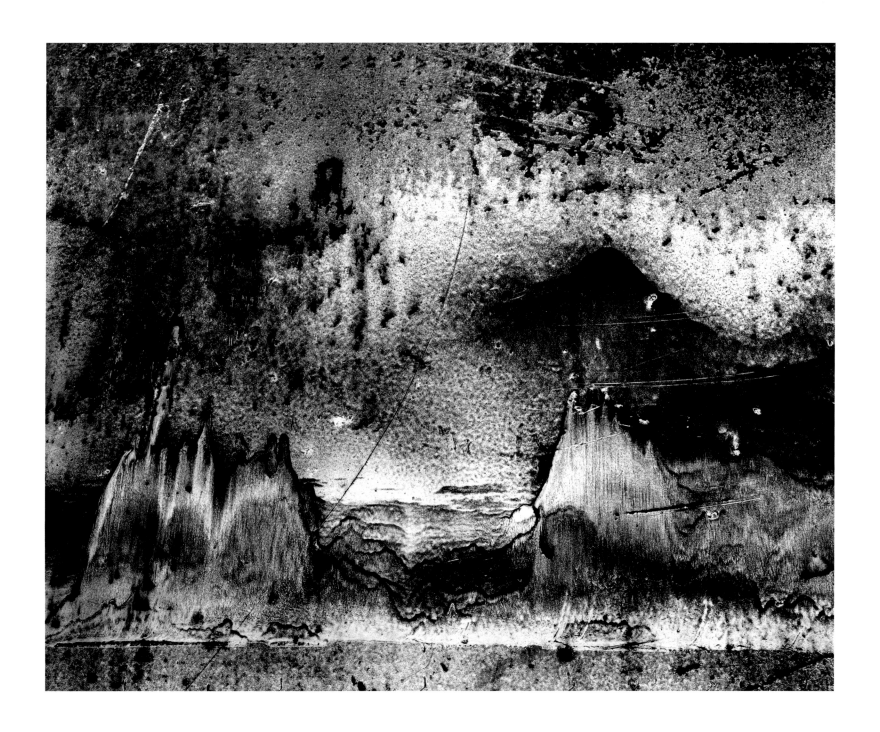

42. Rust and Metal, Argo Mill, Idaho Springs, Colorado, 1974

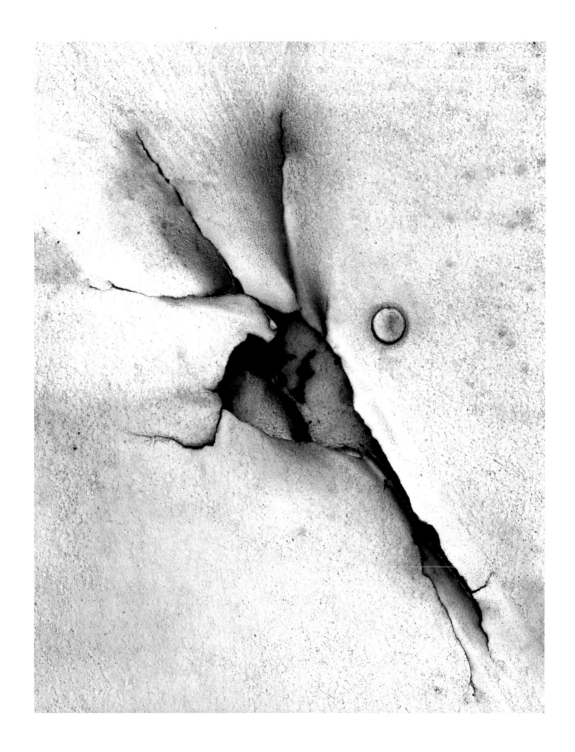

43. Saguaro Cactus Detail, Arizona, 1978

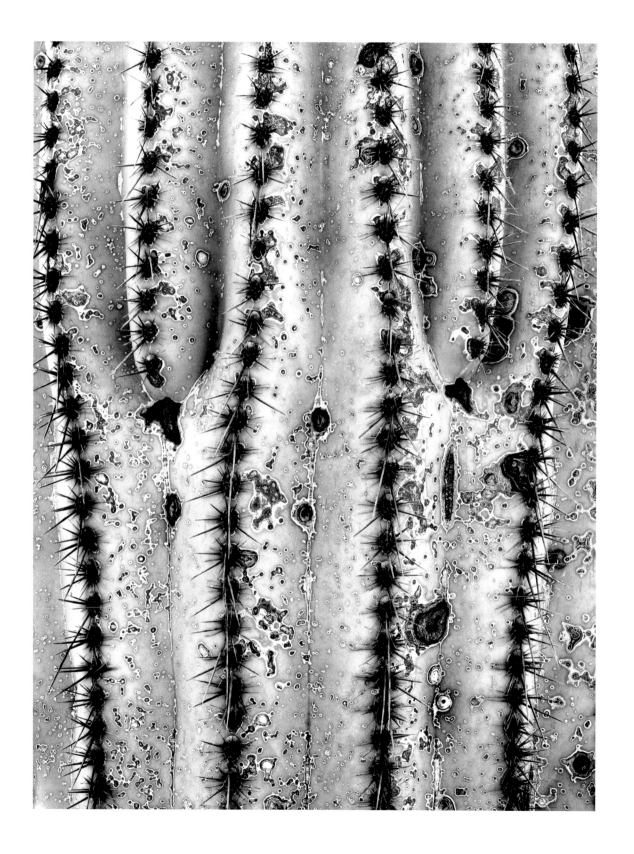

44. Live Oak and Spanish Moss, Brazos Bend State Park, Texas, 1986

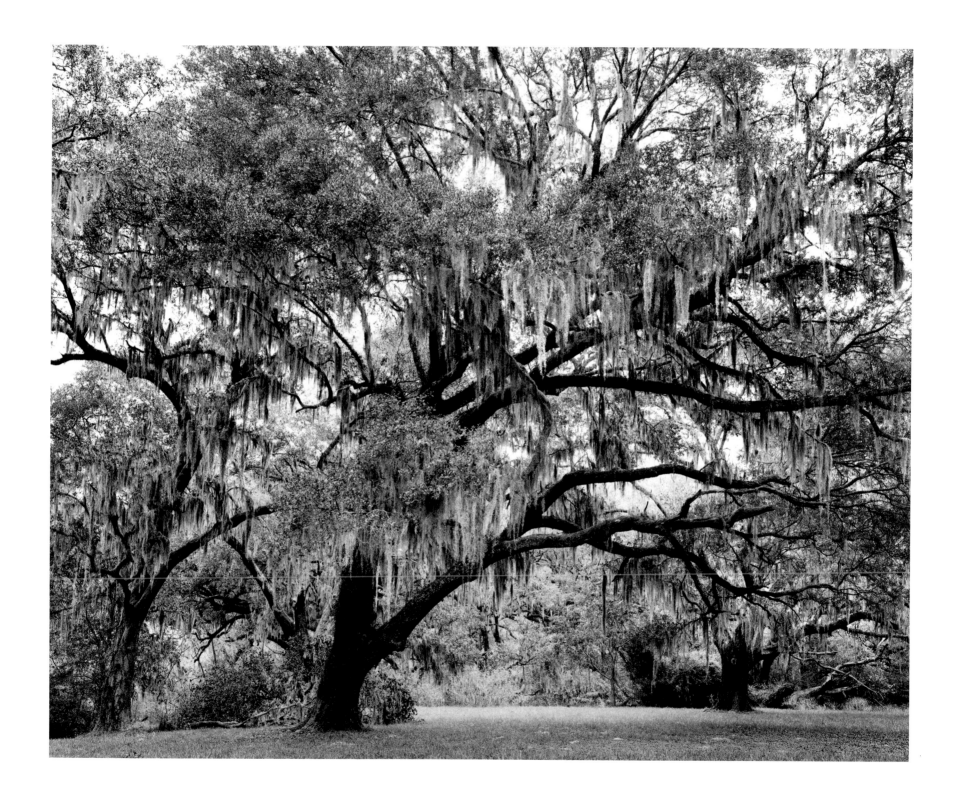

45. Cottonwoods, Capitol Reef National Park, Utah, 1979

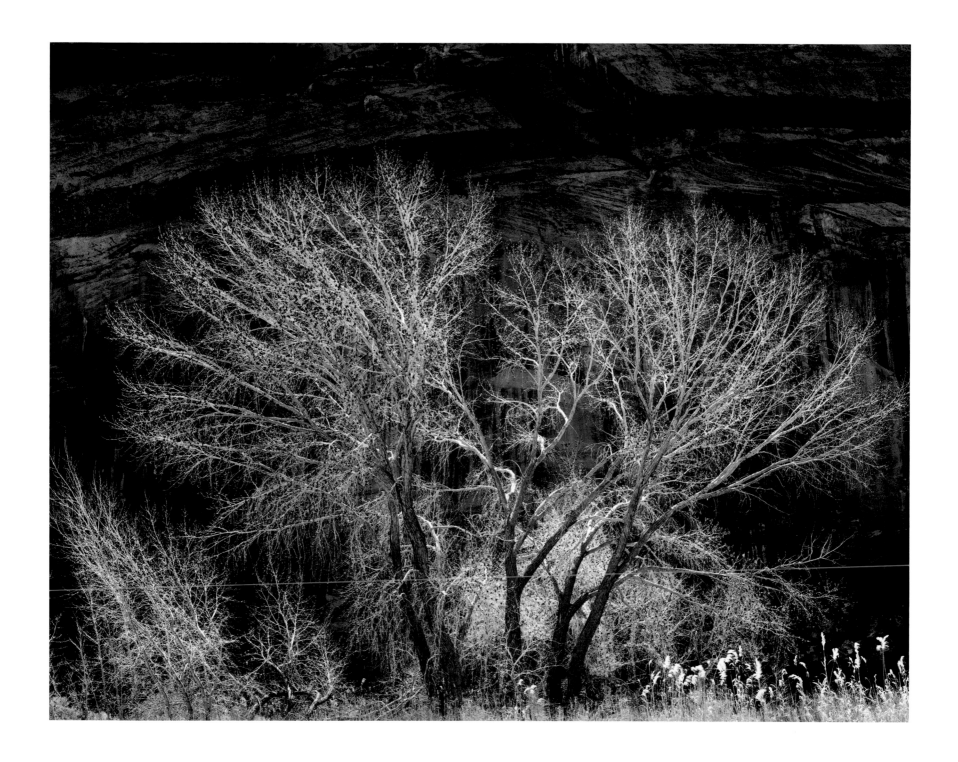

46. Temple of the Sun, Capitol Reef National Park, Utah, 1984

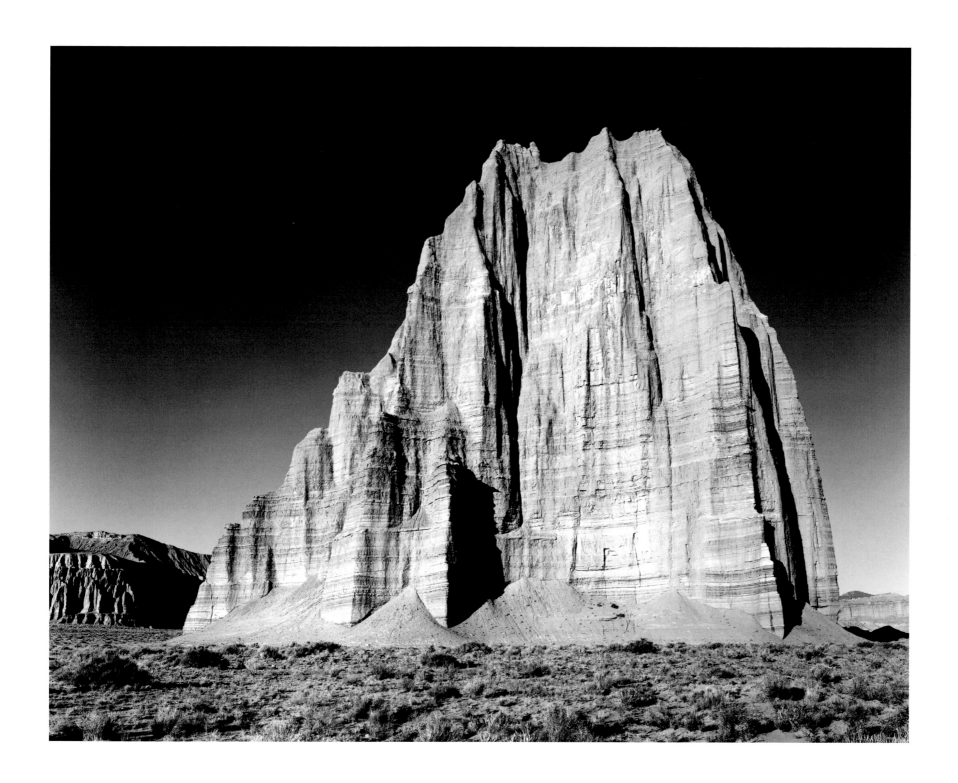

47. Fin, Arches National Park, Utah, 1972

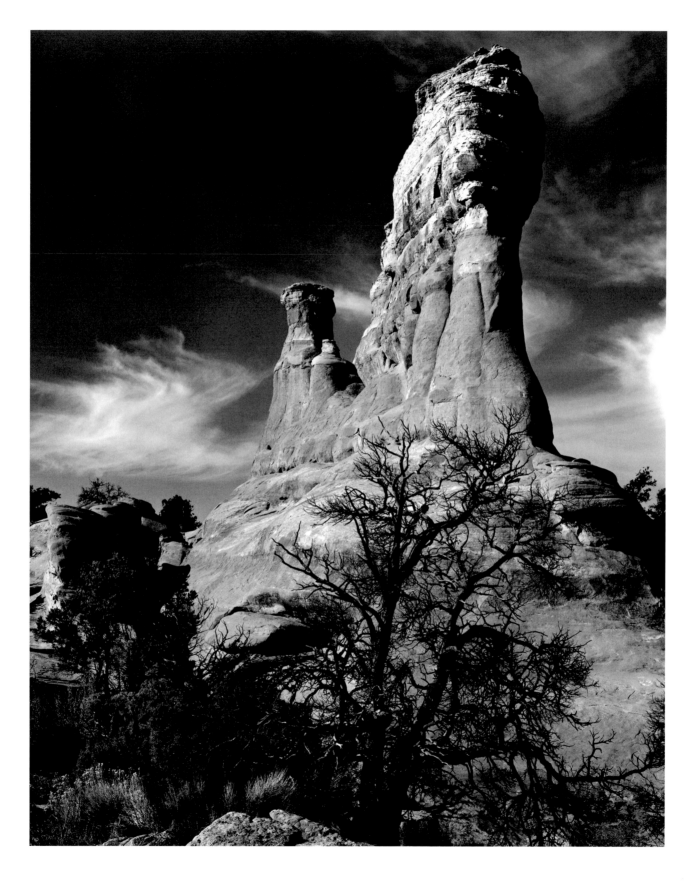

48. Sangre de Cristo Range, Colorado, 1976

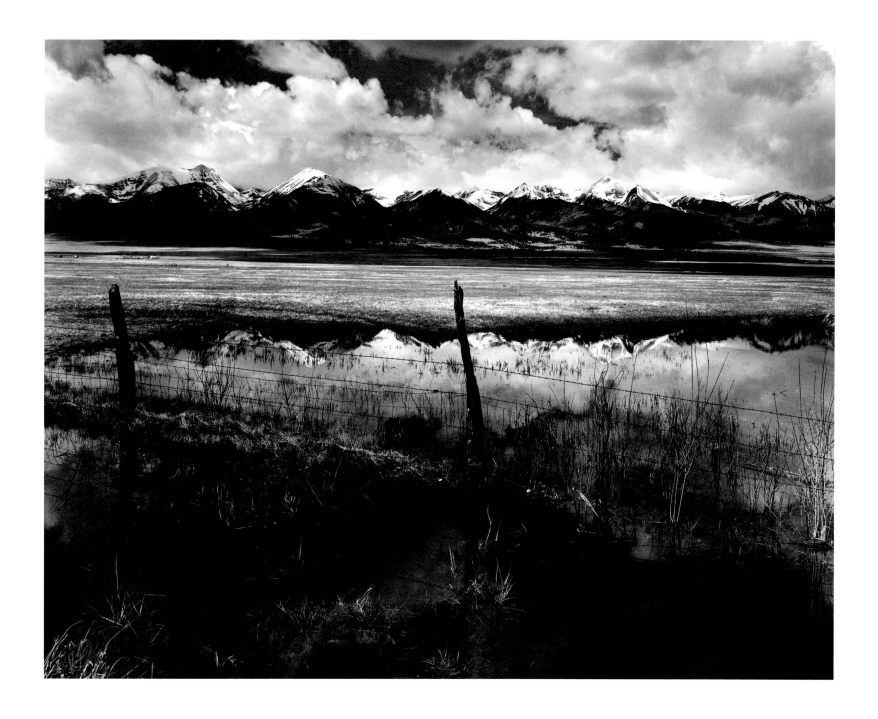

49. Desert View, Grand Canyon National Park, Arizona, 1983

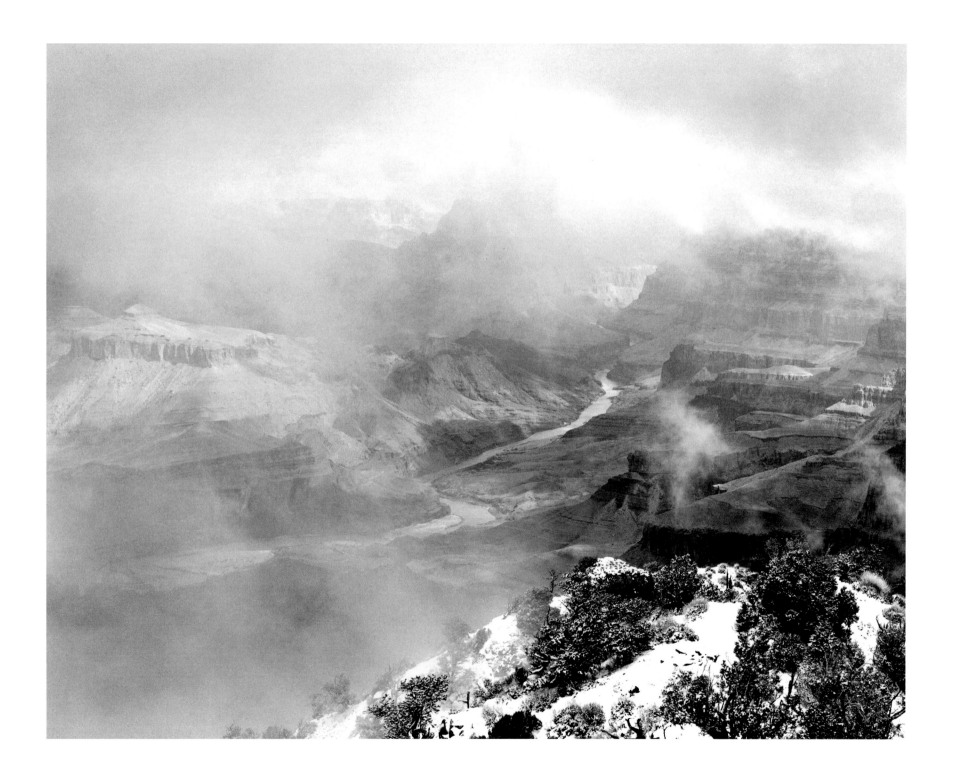

50. Spring Snow, Boulder Mountain Parks, Colorado, 1973

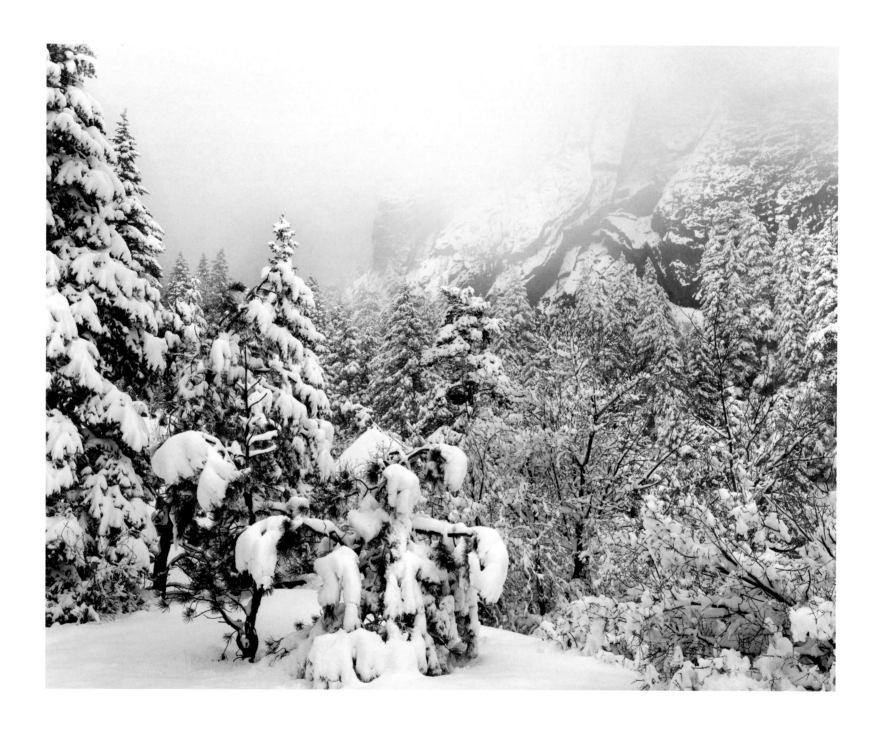

51. Forest, Palmetto State Park, Texas, 1986

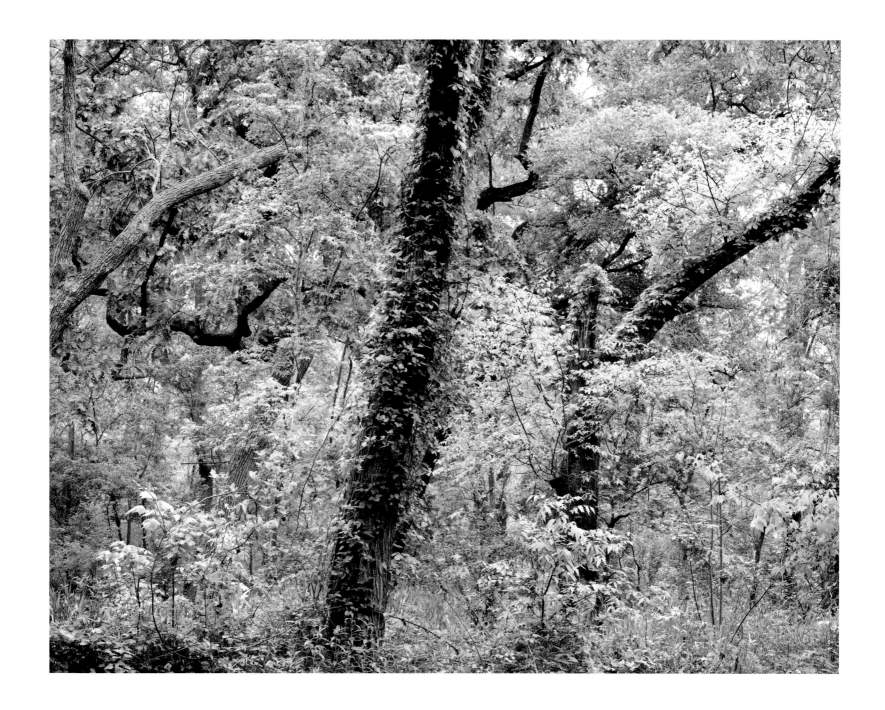

52. Lower Falls in Winter, Bandelier National Monument, New Mexico, 1975

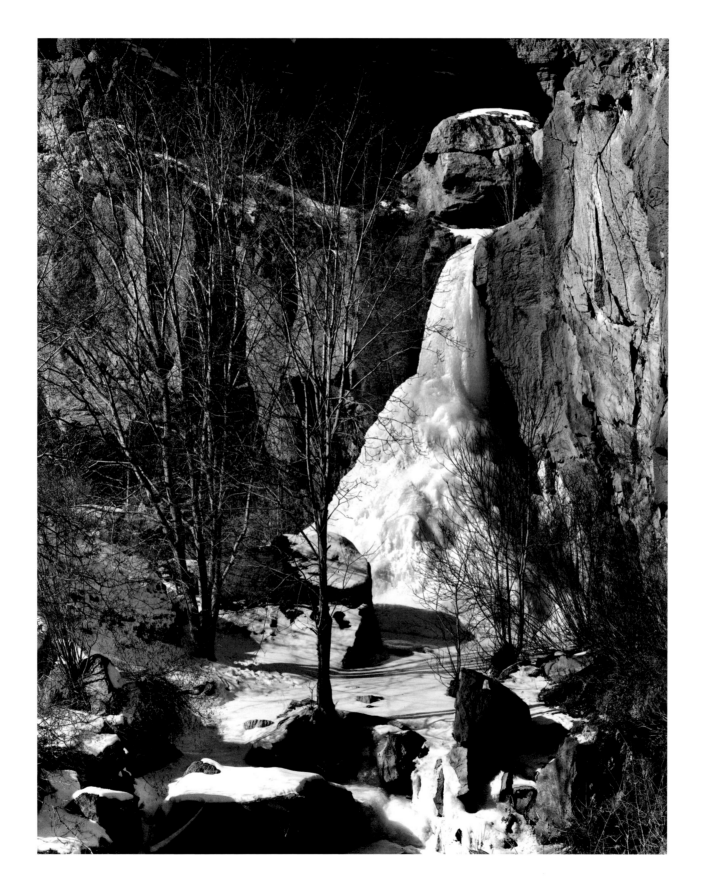

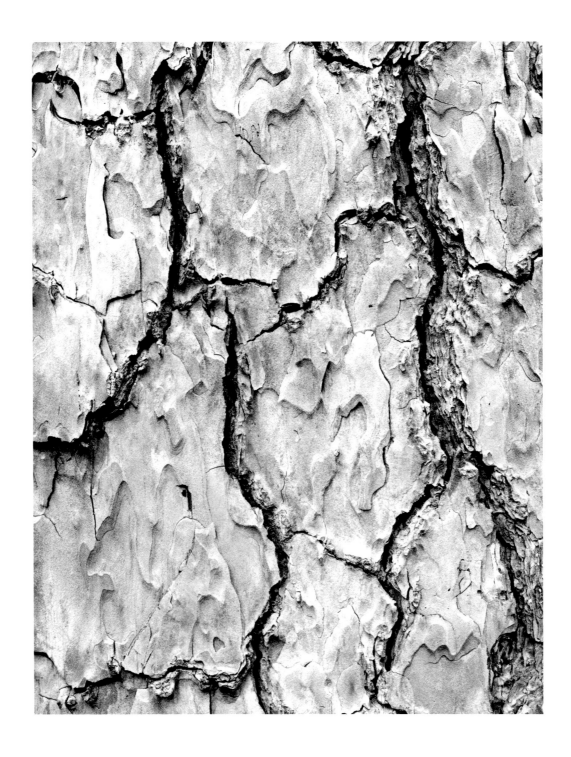

53. Pine Bark, Caddo Lake State Park, Texas, 1986

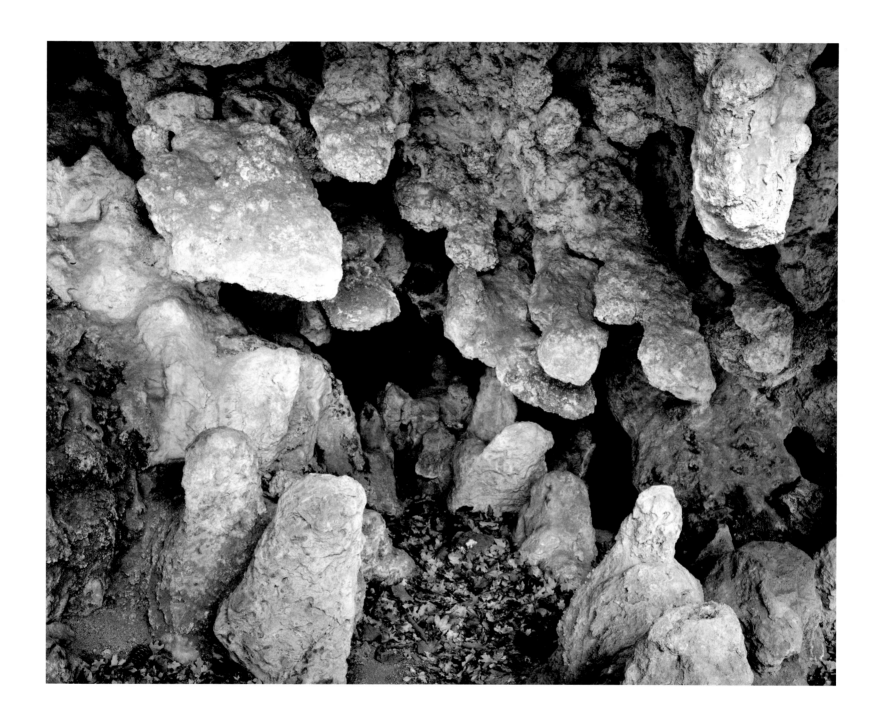

54. Grotto, McKittrick Canyon, Guadalupe Mountains National Park, Texas, 1984

55. Badlands near Zabriskie Point, Death Valley National Monument, California, 1982

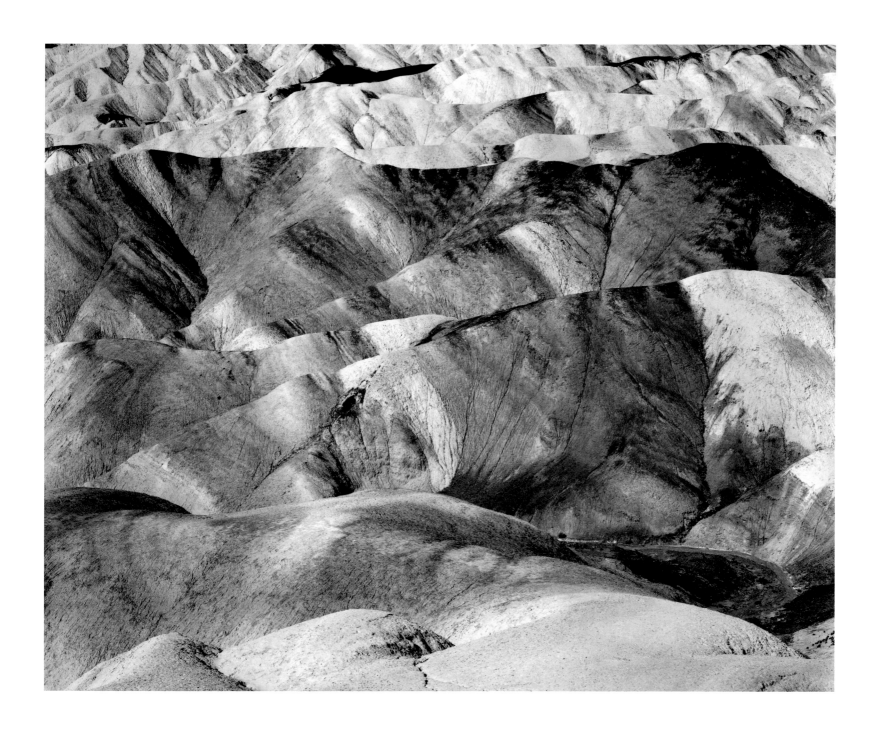

56. Twigs and Snow, Boulder Mountain Parks, Colorado, 1979

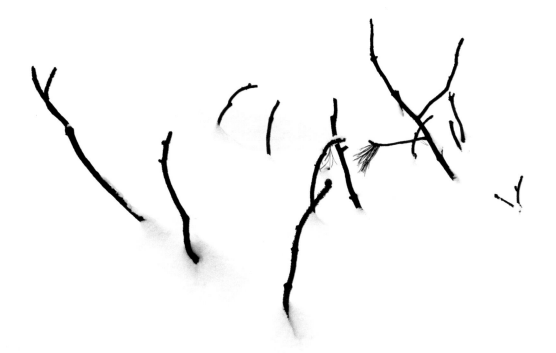

57. November Snow, Chisos Mountains, Big Bend National Park, Texas, 1986

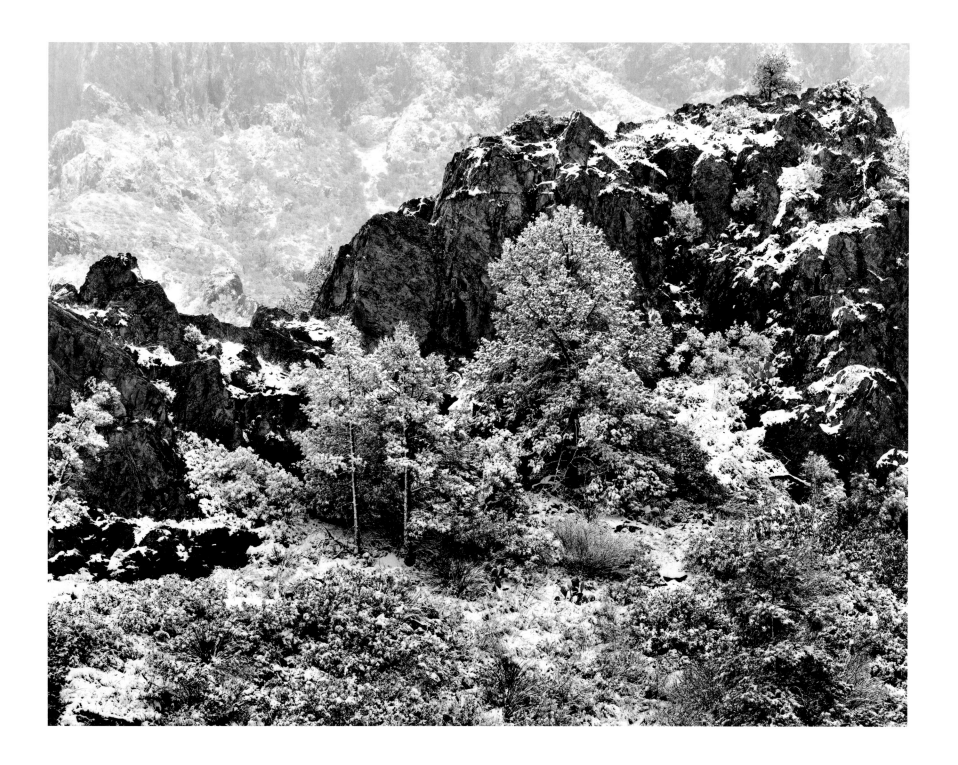

58. Sharkstooth, Rocky Mountain National Park, Colorado, 1978

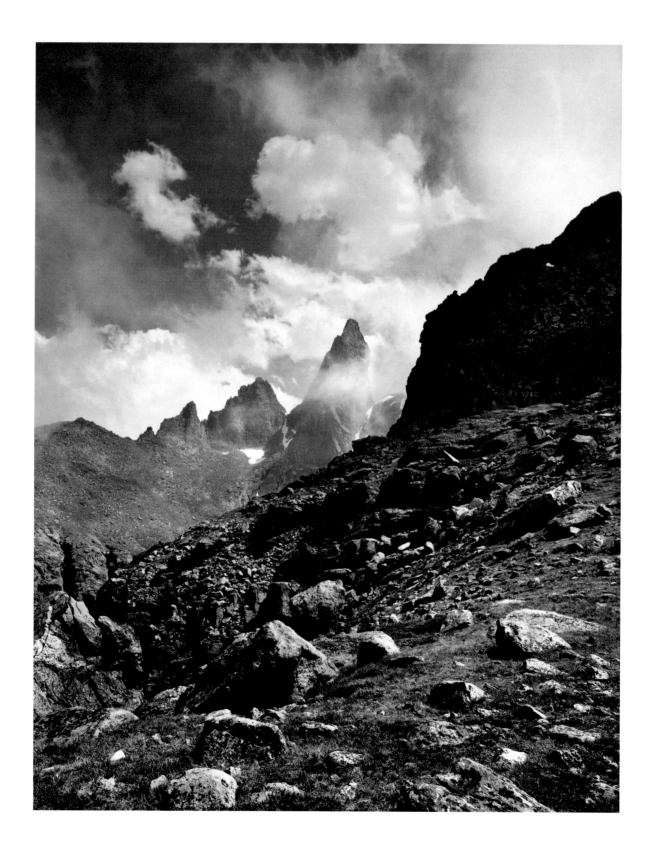

59. Winter Storm, Colorado National Monument, Colorado, 1973

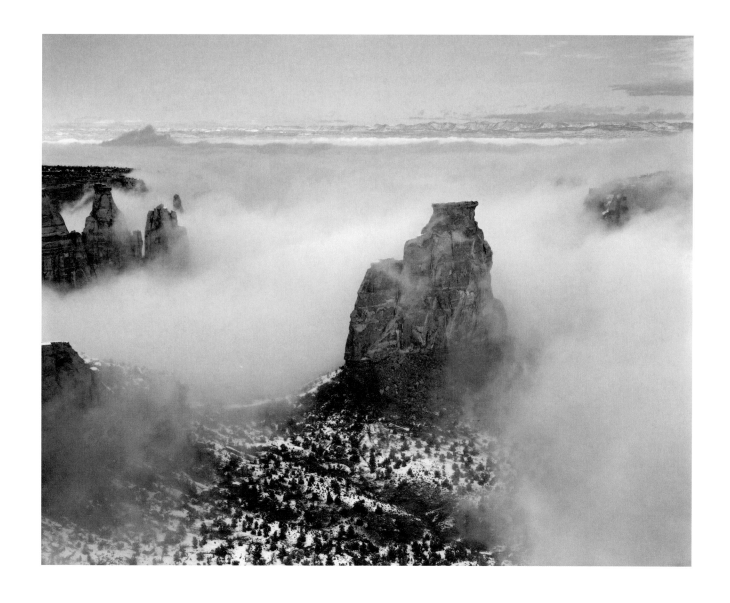

BIOGRAPHY OF JOHN WARD

Born 1943, Washington, D.C.

B.A. (Physics), Harvard University, 1964

Ph.D. (Physics), University of Colorado
at Boulder, 1971

Lives and works in Estes Park, Colorado

1973
Lodestone Gallery, Boulder, Colorado

1975
The Darkroom Gallery, Denver, Colorado

1976
National Center for Atmospheric Research,
Boulder, Colorado

1977
The Darkroom Gallery, Denver, Colorado

1978
Modernage Gallery, New York, New York
The Afterimage Gallery, Dallas, Texas

1979
Eclipse Gallery, Boulder, Colorado
The Darkroom Gallery, Denver, Colorado
Aspen Studio, Woodland Park, Colorado

1980
Hills Gallery, Denver, Colorado

1981
The Halsted Gallery, Birmingham, Michigan
Hills Gallery, Denver, Colorado

1982
Bailey Gallery, Cheyenne, Wyoming
Colorado Mountain College, Leadville, Colorado

1983
Hibberd McGrath Gallery, Keystone, Colorado
Hills Gallery, Denver, Colorado
Denver Center for the Performing Arts,
Denver, Colorado

1984
Eclipse Gallery, Boulder, Colorado
The Grapevine Gallery, Oklahoma City,
Oklahoma

1985
Allen Street Gallery, Dallas, Texas

1986
Denver Center for the Performing Arts,
Denver, Colorado
The Grapevine Gallery, Oklahoma City,
Oklahoma

1987
Gallery 1114, Midland, Texas

1989
The Grapevine Gallery, Oklahoma City,
Oklahoma

1991
Latvian Photographic Arts Society, Riga, Latvia
The Afterimage Gallery, Dallas, Texas

2000
El Paso Museum of Art, El Paso, Texas

SELECTED GROUP EXHIBITIONS

1973
Dallas Museum of Fine Arts, Dallas, Texas

1974
Jewish Community Center, Denver, Colorado

1978
The Gallery of Photographic Arts,
North Olmsted, Ohio
The Foothills Art Center, Golden, Colorado

1979
Douglas Kenyon Gallery, Chicago, Illinois

1980
The Keystone Gallery, Santa Barbara, California

1981
Silver Image Gallery, Seattle, Washington
Wach/Edwards Galleries, Houston, Texas

1982
Union League Club of Chicago, Chicago, Illinois

1983
The Martin Gallery, Washington, D.C.

1984
The Ginny Williams Gallery, Denver, Colorado

1985
The Foothills Art Center, Golden, Colorado

1987
The Rockwell Museum, Corning, New York

1988
Western Colorado Center for the Arts,
Grand Junction, Colorado

1990
Doremus Gallery, Peters Valley Craft Center,
Layton, New Jersey
Art Center of Estes Park, Estes Park, Colorado

1991
Boulder Art Center, Boulder, Colorado
The Afterimage Gallery, Dallas, Texas

1992
Santa Barbara Museum of Art, Santa Barbara,
California

1994
Santa Barbara Museum of Art, Santa Barbara,
California

1996
The Afterimage Gallery, Dallas, Texas

1997
Cultural Arts Council of Estes Park, Estes
Park, Colorado

1999
Carol Keller Gallery and Colorado Photographic
Arts Center, Denver, Colorado

2000
The Foothills Art Center, Golden, Colorado

2001
El Paso Museum of Art, El Paso, Texas

2002
El Paso Museum of Art, El Paso, Texas

SELECTED PUBLIC COLLECTIONS

Amon Carter Museum, Fort Worth, Texas

Albin O. Kuhn Library and Gallery, University
of Maryland, Baltimore County, Maryland

Center for Creative Photography, University
of Arizona, Tucson, Arizona

Colorado Historical Society, Denver, Colorado

Denver Art Museum, Denver, Colorado

Denver Public Library, Denver, Colorado

Detroit Institute of Arts, Detroit, Michigan

El Paso Museum of Art, El Paso, Texas

Grand Valley State University, Allendale,
Michigan

Santa Barbara Museum of Art, Santa Barbara,
California

SELECTED PUBLICATIONS BY JOHN WARD

John Ward: Landscape, Portfolio One (12 prints,
edition 50), 1981

Colorado: Magnificent Wilderness, Westcliffe
Publishers, Inc., 1984

ACKNOWLEDGMENTS

Beyond the support of family, to acknowledge the names for a lifetime of work is to miss names. Yet the muse does not live by inspiration alone. Therefore I wish to thank all of those, most unknown, who have contributed to that lifetime of work by purchase of the things Susan and I have made, from our lowliest beads to our finest pottery and prints.

The title of this book derives from *Land and Light*, a 1982 exhibition of my work at the Bailey Gallery in Cheyenne, Wyoming. I have long thought this an effective description and I thank them for the insight.

I would also be remiss if I did not thank, with pleasure, the people at the El Paso Museum of Art, from administrators and employees to the many supporters of the Museum. The same must be said for Trinity University Press and all those who played a role in the design and production process. The photographs are mine, but this book is their creation.

Three people cannot escape my aversion to names. Jim Haines is acknowledged for his stewardship of the prints I gave him, but mostly I treasure him for years of friendship, endless hours of conversation, some Kansas ghost towns, and many miles of hiking. In the beginning, Bill Thompson, who curated with great sensitivity a small exhibition of my work at the El Paso Museum of Art, said a book was a good idea but he would not have time to write the text. In the end, he wrote a splendid essay and did far more than I can possibly imagine to make this book real.

Finally, and most important, I thank Susan for her lifetime of love and support. Except for her insistence on the cross, I take credit for these photographs, but I share it all with Susan.

—*John Ward*

John and Susan Ward have been involved with every aspect of this project since the beginning. I thank them both for their enthusiasm, hard work, patience, and gracious hospitality during my visits to their Colorado home.

Becky Duval Reese and the entire staff of the El Paso Museum of Art have worked diligently behind the scenes to coordinate the many fine details. It was also a pleasure to work with Barbara Ras and Sarah Nawrocki at Trinity University Press, copyeditor Christi Stanforth, designer Karen Schober, and printing consultant David Peattie, who expertly saw this book through to completion.

I am grateful to the many individuals who assisted with my research and particularly for the information and feedback provided by Jim Bones, Bill Lees, David Rathbun, Ray Whiting, Margaret Ward, Ronald Wohlauer, and the staff of the Special Collections Department at Norlin Library, University of Colorado at Boulder. Diane Lovejoy, director of publications at the Museum of Fine Arts, Houston, and photographer David Plowden also provided welcome advice.

On a final note, I too wish to express my appreciation to Jim Haines for introducing so many of us to the photography of John Ward.

—*William R. Thompson*